大悲咒

郎敬文

hamah ratna trayáya
禮敬　　三寶

namo áryá Valokite svaráya bodhi sattvaya mahá sattvaya
禮敬 聖者 觀 自在 菩薩． 大菩薩

mahá káruņikaya om sarva rabhaye sudhanadasya
大 慈悲者 ～ 一切 讚佈 心生清淨

namas-krtva imam-áryá Valokite svara ramdhara
今所礼敬 彼聖者 觀自在 善者

namo norakindi hrih mahá vat svaäne
礼敬 青頸觀音 ～ 大 菩提心．

Sarva arthato subham ajeyam
一切 煩惱盡除 無量功德

sarva sattva nomo vasattva namo vaka
一切 氣生 礼敬 婆婆世界 礼敬 唱調

咒文

mari tato tadyathä om avaloki lokate krate e hrih
遠離束縛 即說咒曰 觀照世界 礼祥 ～

mahá bodhi-sattva sarva sarva
大 菩薩 一切 一切

mala mala mahima hrdayam
清淨 無染 偉大 自在心

kura kura karmam dhuru dhura vijayate mahá-vijayate
造 業 堅守 勝利 大 勝等者

①

catch

catch your eyes ; catch your heart ; catch your mind······

「佛」（Buddha）是從天竺（古印度（傳入西域（翻
譯成「浮屠」）、再傳入唐朝之音譯簡稱，用當年官
話（河洛語）發音似閩南語唸「佛」矣，簡單說就是
「覺悟者」之意，覺一切有情眾生之苦，以般若智慧
離苦得樂，因此「佛」不是「神」，是深解如來密義者
也。人以如來、世尊、正遍知、世間解、調御丈夫…等
十種尊號通稱，三世諸佛皆因因緣俱足誕生世間說法
不但自覺、覺他更令眾生覺滿，度一切苦厄。然而在
世間享盡榮華富貴的悉達多太子棄轉輪聖王不當，前
住雪山密林勤修苦行六年究竟覺悟了什麼？六道輪迴
永無休止，平等一切眾生可能嗎？

「佛陀」是修頭陀苦行而覺悟者，釋迦摩尼佛在
一千五百多年前於菩提樹下證得「阿耨多羅三藐三菩
提」（無上正等正覺）之前，魔王曾指派代表貪、嗔
痴三位女兒迷惑世尊，見其不為所動再派出千軍萬馬
威脅，然而千萬煩惱箭雨落下變成漫天花朵飄散，此
時若被引誘而生邪淫慢心易入魔道，即所謂「走火入
魔」被巨大妄想蒙蔽，迷於魔境而不自知，非但「我
執」未破，還執迷於「法執」與「外相」，不但無法
入般若空性，甚至執「空」、「有」二邊，而落入「當
見」（生生世世皆可為人）與「斷見」（無有來世因
果業力），因此無所謂惡行或善舉，皆可投胎轉世為
人，若生而為人立足世上無慚、無愧、無羞、無恥、
無信乃至於薄情寡義、放浪形骸、邪淫奸佞、與禽獸
比之何異也？

「大佛頂如來密因修證了義諸菩薩萬行首楞嚴經」

乃破魔經王，藉由阿難與摩登伽女宿世因緣遭邪淫之術將毀戒體，文殊室利菩薩持楞嚴咒前往破魔，因此因緣導致後來佛對阿難說法「七處破妄」（心不在內、心不在外、心不在眼根、二個識知之心、心無本體、心不在中間、不執著之心非本性）與「十番顯見」（指見性是心非眼、客塵顯見心不動、觀河顯見性無遷、垂手顯見心無滅、標指顯見性非物、無是非是性為真、性非因緣非自然、二妄顯見性非見、破和合見如來藏），對話之間點出應無所住心，再以「二十五圓通」請大阿羅漢、菩薩分享修行心得，最後以五蘊（色、受、想、行、識）各十處魔境總和「五十陰魔」，佛陀藉此告知世人魔從心生、心無外魔，切勿著相。

心識甚為微妙，動念乃至剎塵，所有行為造作皆來目起心動念，因此大乘佛教以「百法明門」歸納出「有為法」，分為「心法八識」（眼、耳、鼻、舌、身、意，末那識、阿賴耶識）、五十一種「心所有法」（遍行五、別境五、善十一、煩惱六、隨煩惱二十、不定四），其中貪、瞋、痴、慢、疑、惡見乃「根本煩惱」，二十個「隨煩惱」為忿、恨、惱、覆、誑、諂、憍、害、嫉、慳、無慚、無愧、不信、懈怠、放逸、惛沈、掉舉、失念、不正知、散亂為世人常犯之舉，「心不相應行法」則有二十四種（得、命根、眾同分、異生性、無想定、滅盡定、無想報、名身、句身、文身、生、老、住、無常、流轉、定異、相應、勢速、次第、方、時、數、和合性、不和合性），色法十一款（眼、耳、鼻、古、身、色、聲、香、味、觸、法處所攝色），構成

九十四種「有爲法」，指所有造作、變動、消亡、因
緣和合而生現行造業，至於六個「無爲法」爲本體界，
包括虛空無爲、擇滅無爲、非擇滅無爲、不動無爲、
滅受想無爲、眞如無爲，指本自具足，不依賴外緣而
存在之法。

佛陀入大般涅槃前曾囑咐阿難依「四念處」（觀身
不淨、觀受是苦、觀心無我、觀法無常）而住，以「戒」
（不殺生、不邪淫、不偷竊、不妄語、不惡口、不兩舌、
不綺語、不貪、不嗔、不痴）爲師，依法不依人，連
「空相」都不應執著，何況是用木石所刻之外相？因
此釋迦摩尼佛入滅後五、六百年並無佛像供人膜拜，
頂多造塔寺紀念，皆以象徵手法（法輪、紋飾、菩提
樹、台座、佛龕……）弘法，直至貴霜王朝以犍陀羅
（Gandhāra，位於巴基斯坦與阿富汗一帶）和秣菟羅
（Mathurā，位於印度中北部）爲中心，才逐漸發展出
佛陀三十二相、八十種隨行好，讓信徒可以頂禮膜拜，
開始進入神格化時期，歷經近二千年，無論是南傳、
藏傳、漢傳、東密……皆發展出系統縝密、各具風格、
精雕細琢之佛像與繁複儀軌，讓世人一窺佛教藝術博
大精深。

然而世風日下、人心不古，許多宗教團體假慈善事
業行個人崇拜與斂財之實，附佛外道橫行寶島洗腦者
眾，自稱活佛、發大妄語者不乏其人，入「魔地（泥
濘）」（Muddy）如陷「塵沙惑」而無法自拔，假「佛
（覺者）」（Buddha）之義名聞利養、行教主個人崇拜
或以神通示人，蒙蔽「五蘊」（色、受、想、行、識）

堕入無盡權力、慾望、財富、外相之追求，離根本解脫、無有罣礙、畢竟空皆遙不可及，起心一刹那、一念三千年，西方極樂世界與無間地獄懸於念起、覺遲之間，沒有天堂何來地獄？若所有人類終將成爲鬼魅幻影，那何謂死亡？又如何出脫「三界」（欲界四天、色界十八天、無色界四空天）呢？

在此瘟疫爆發、戰火彌漫之五濁惡世，面對宇宙意識、人生去來、因果輪迴、業力爆發等人生終極課題，不禁深覺人類出現地球不過數十萬年，卻因無盡貪婪、鬥爭堅固、強取豪奪、迷失本眞，濫捕嗜殺導致物種大量滅絕，工業革命、資本主義、全球化加速耗盡星球資源，無怪乎富豪、政客不吝豪擲投資馬斯克飛往火星計畫，與其遷往它星居住換來人類永世綿延，也許換個念頭、改變價值觀與萬物共榮共存可能是更佳選擇。地球在浩瀚宇宙不斷高速旋轉，萬物皆在漩渦狀態，人心慾望被無所不在之暗物質捲入洪流，人類心識若入魔扭曲，是否最終也會坍塌成無數黑洞吞食一切物質？

身爲手無縛雞力、乏撼動山河勢、無病愛呻吟之大叔藝術家，面對疫情一籌莫展，雖非社會賢達也非文人雅士，對於過往二年有餘、世界被莫名按下暫停鍵總該有此表示，試圖透過十餘年來所攝黑白底片反思楞嚴經「相皆虛妄」要旨，與其稱此書爲「警世圖鑑」，也許人們更需要乃醍醐灌頂之「破魔心咒」矣！

姚瑞中 2022 年夏至寫於幻影堂（The illusion）

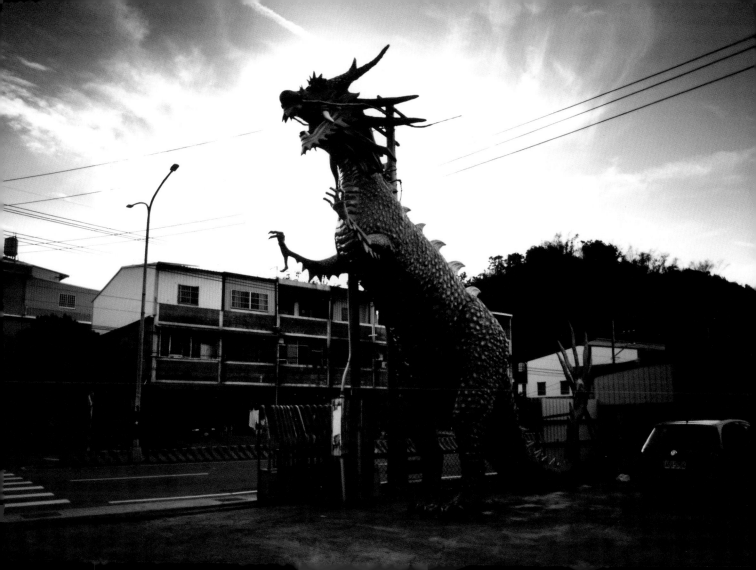

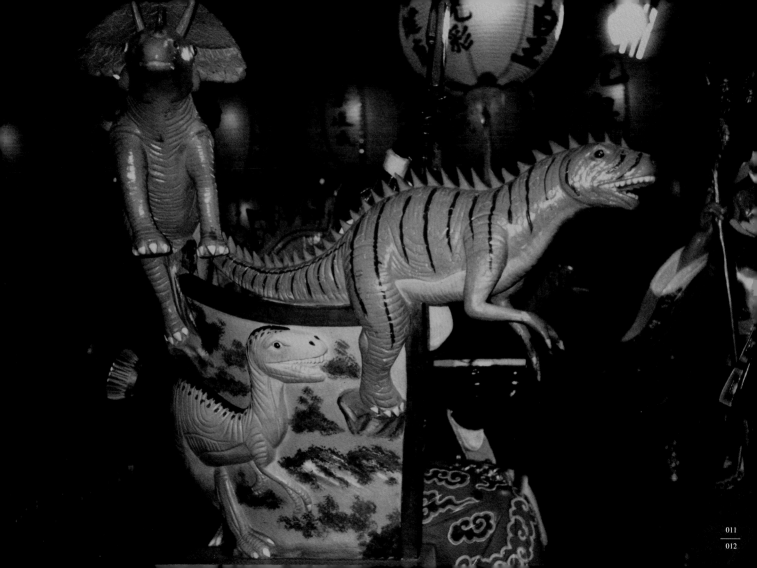

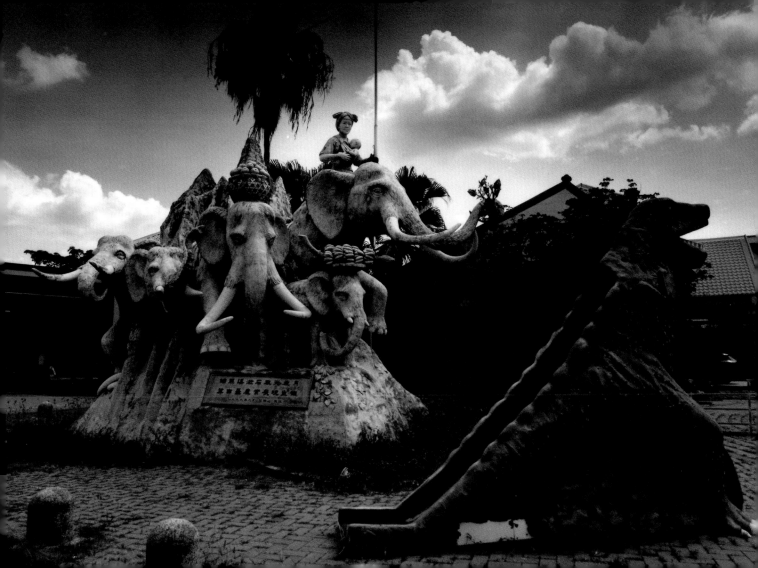

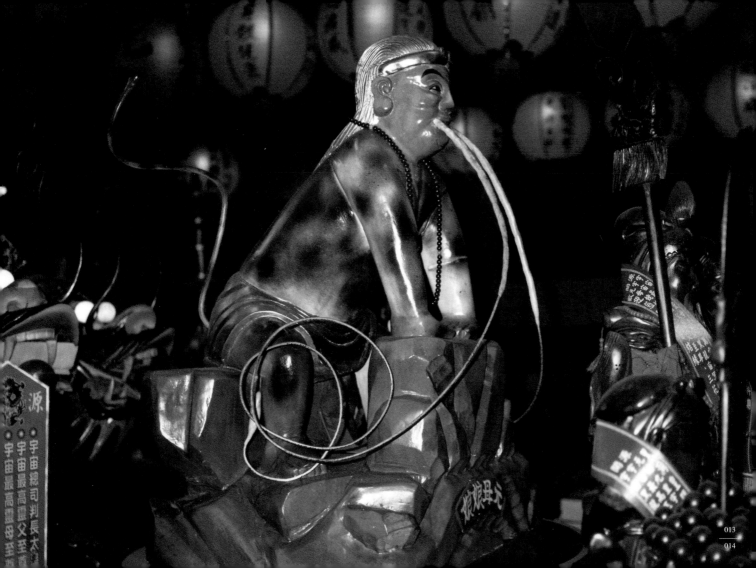

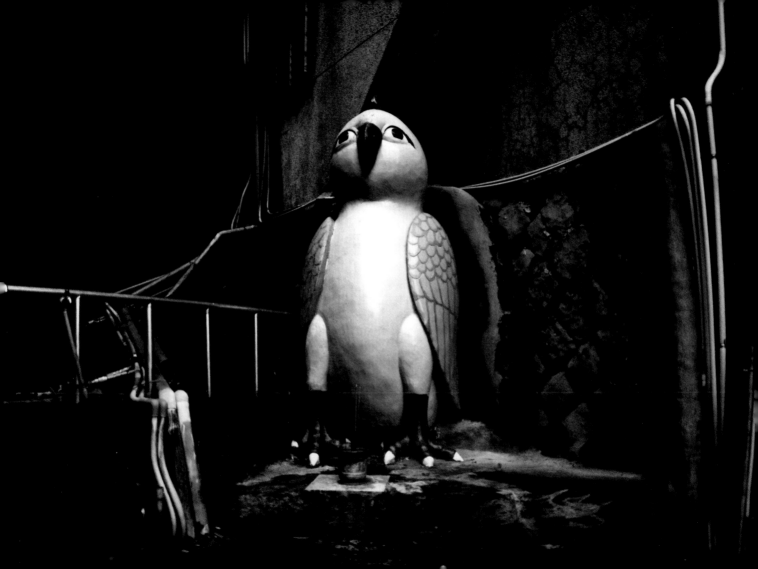

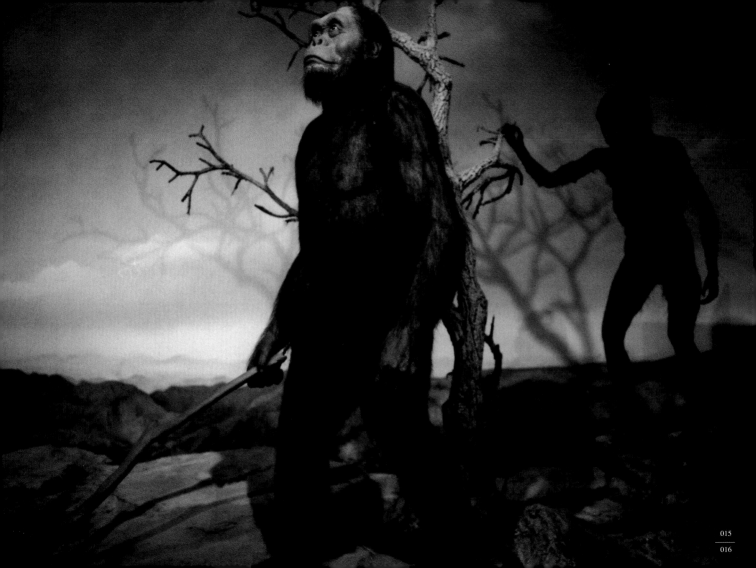

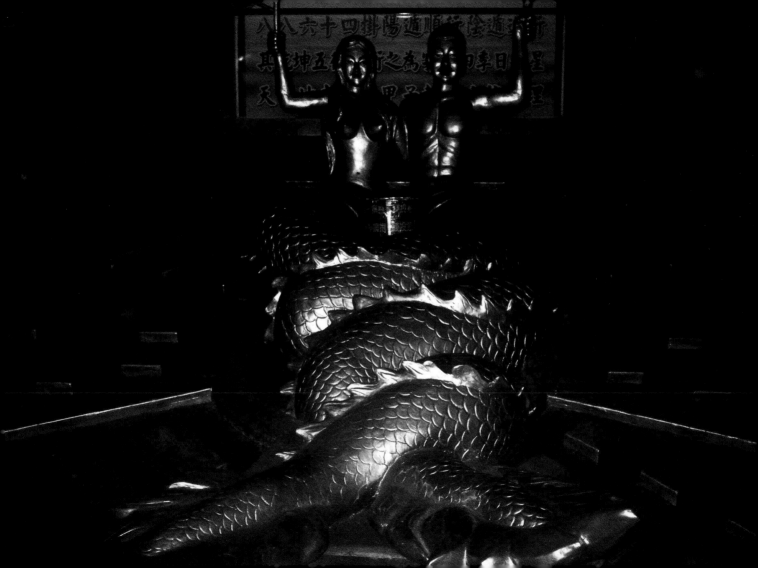

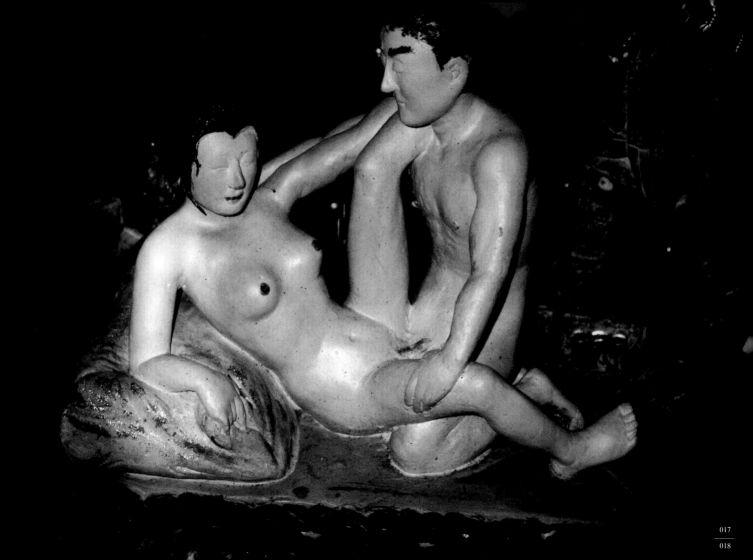

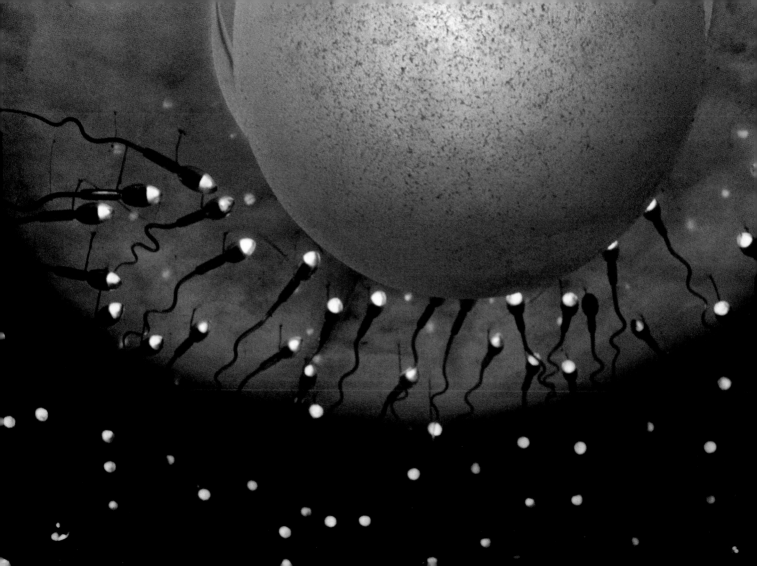

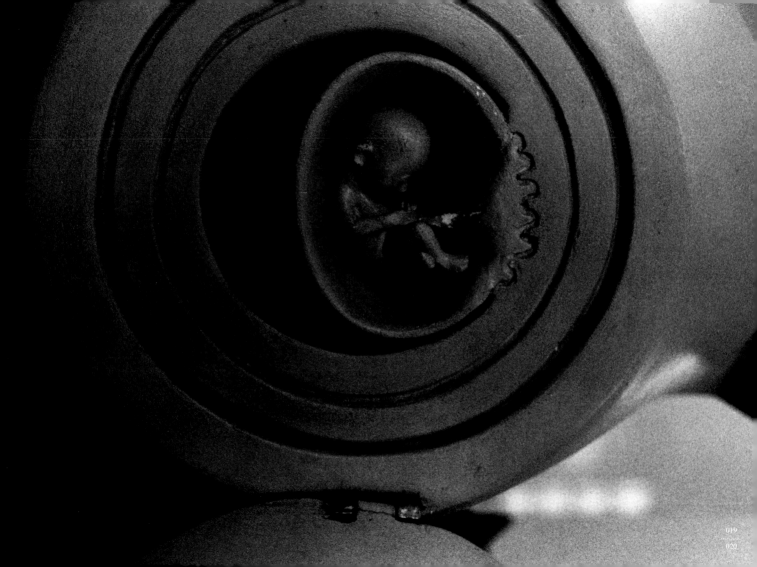

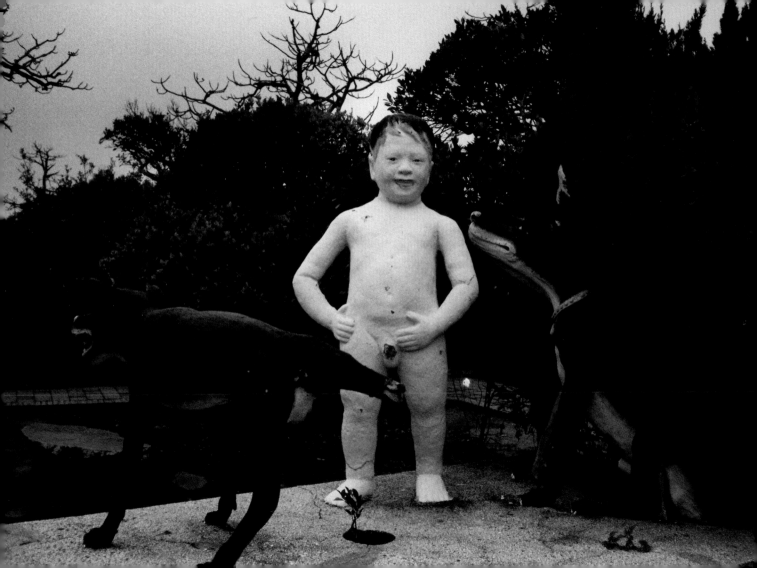

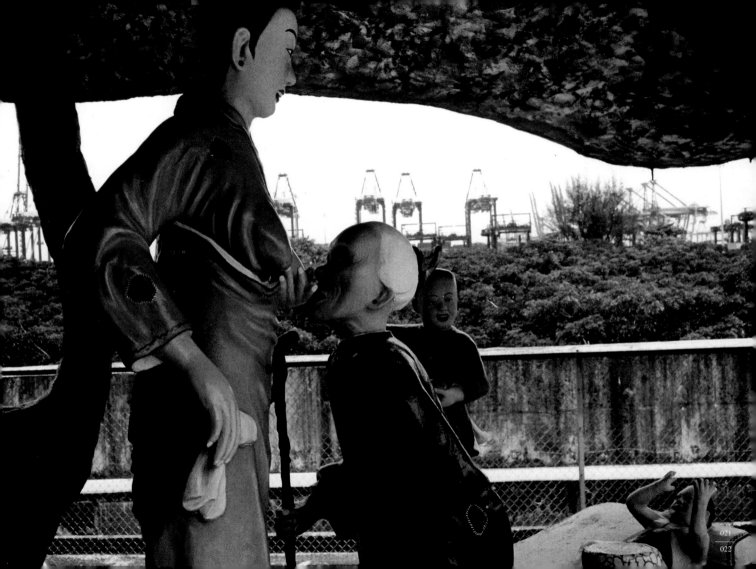

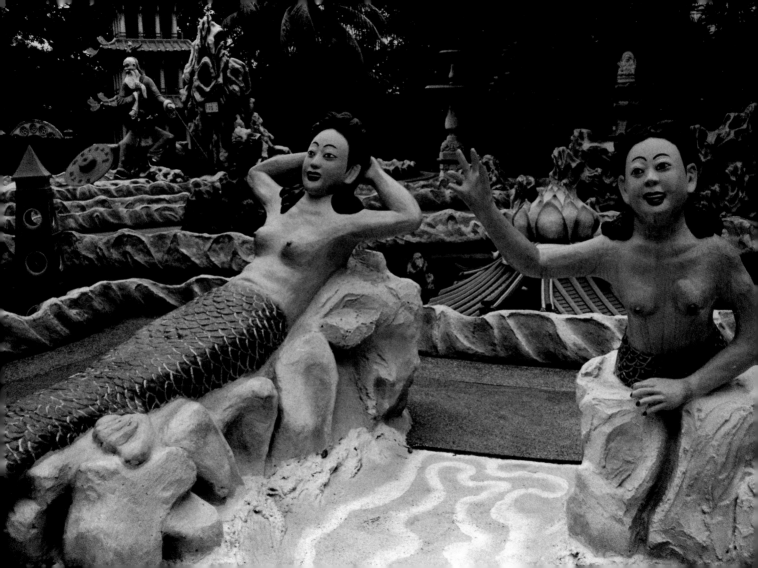

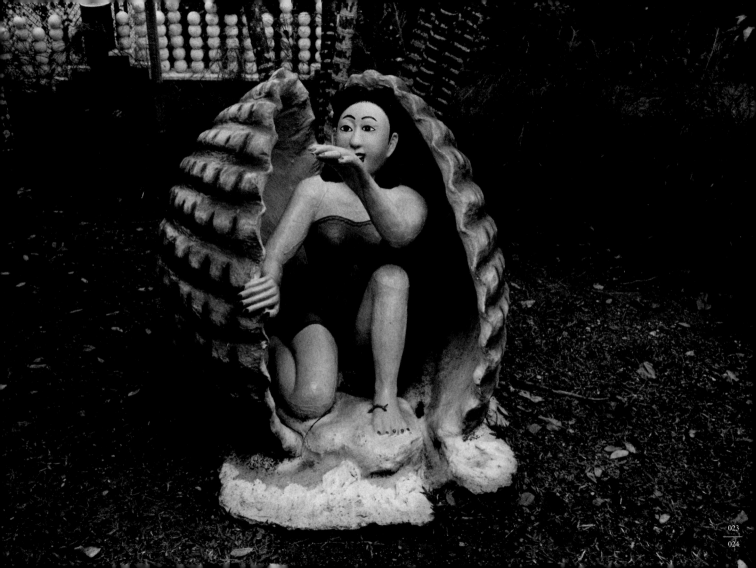

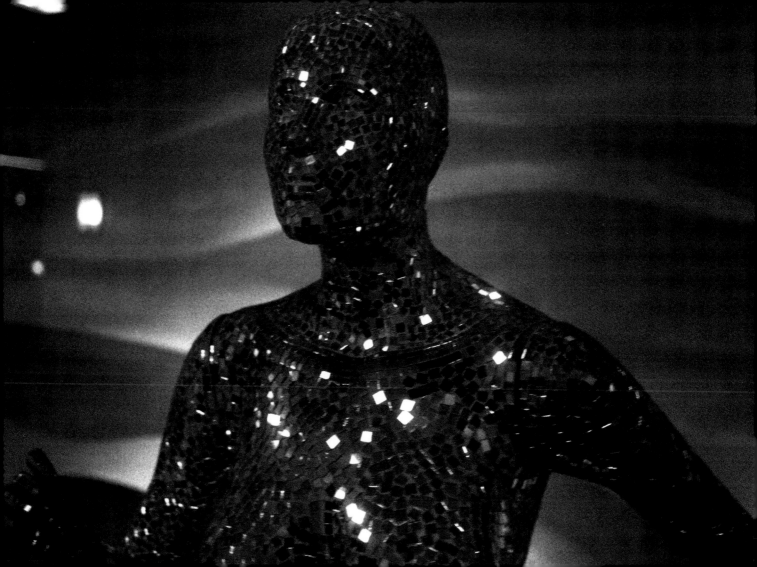

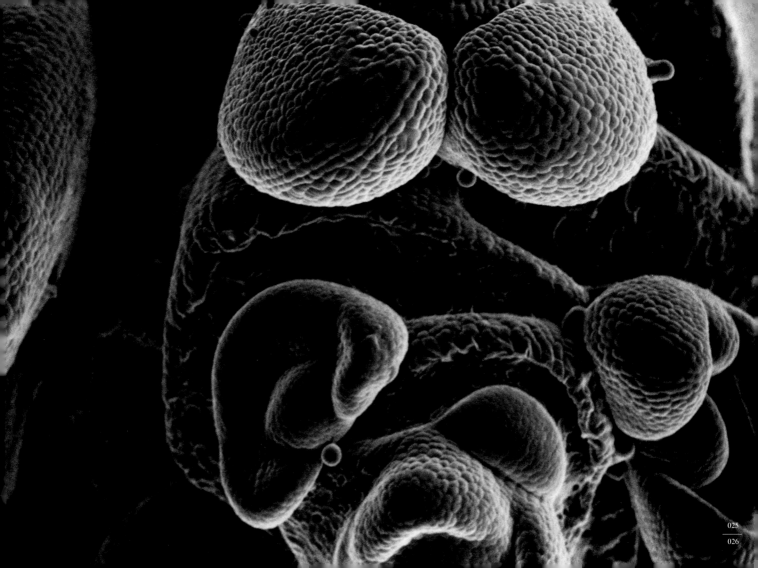

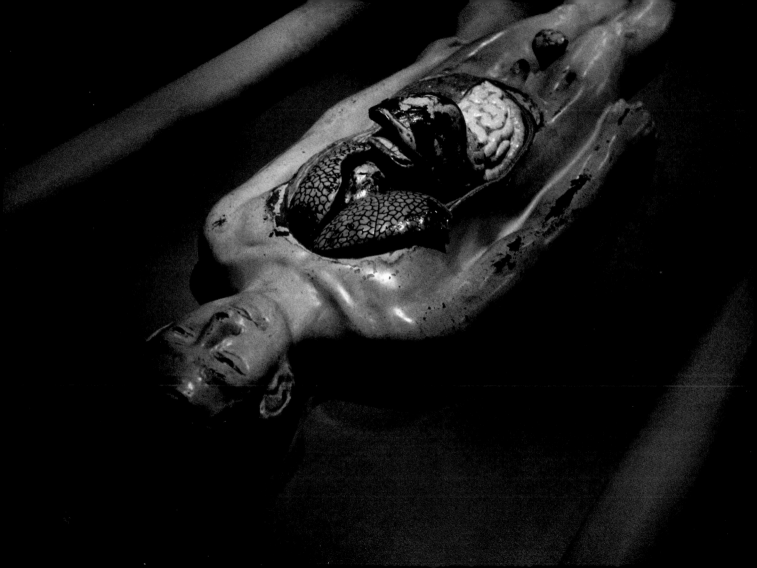

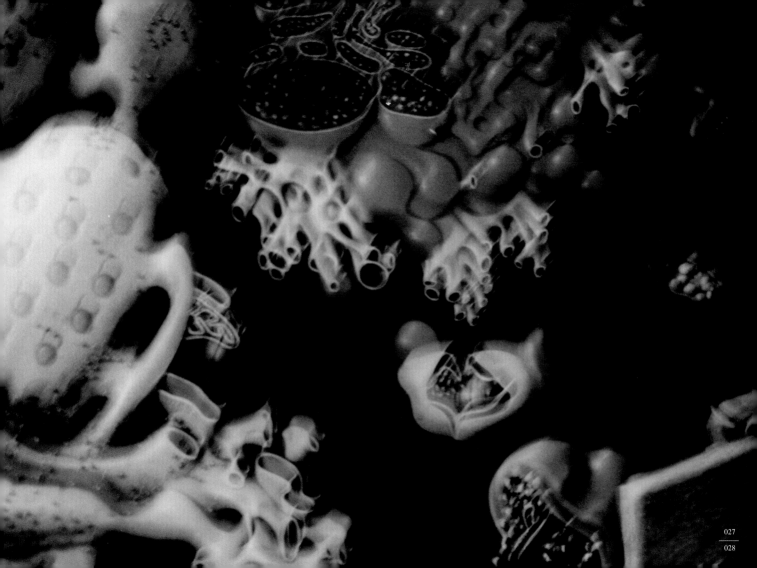

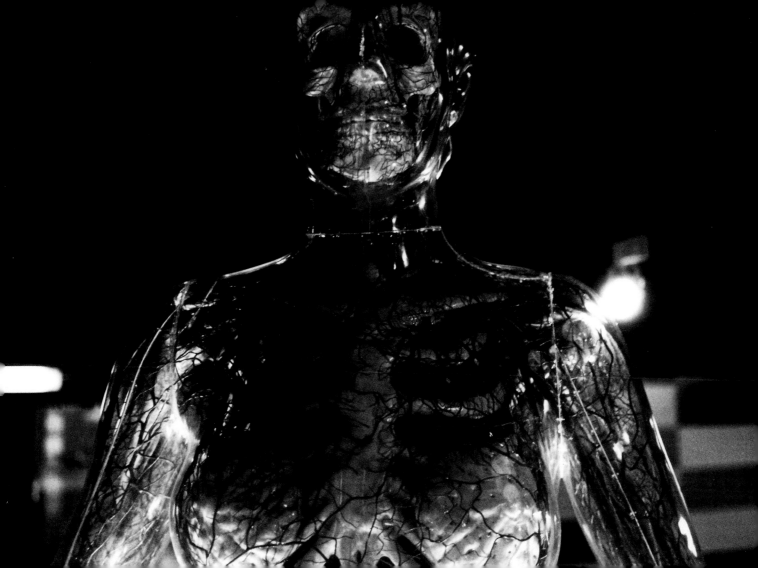

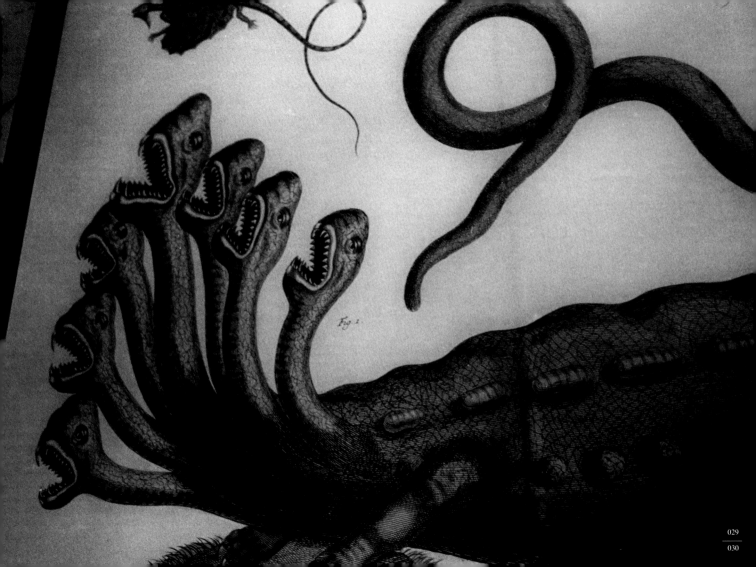

Fig. 1.

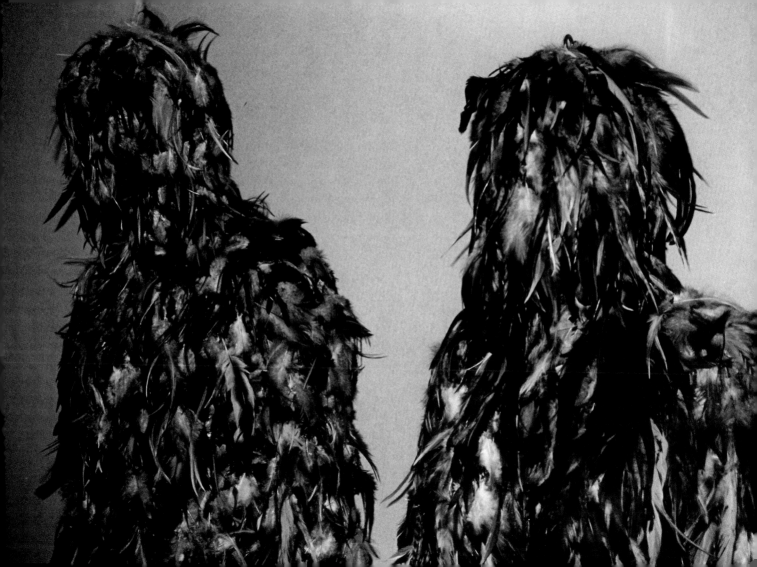

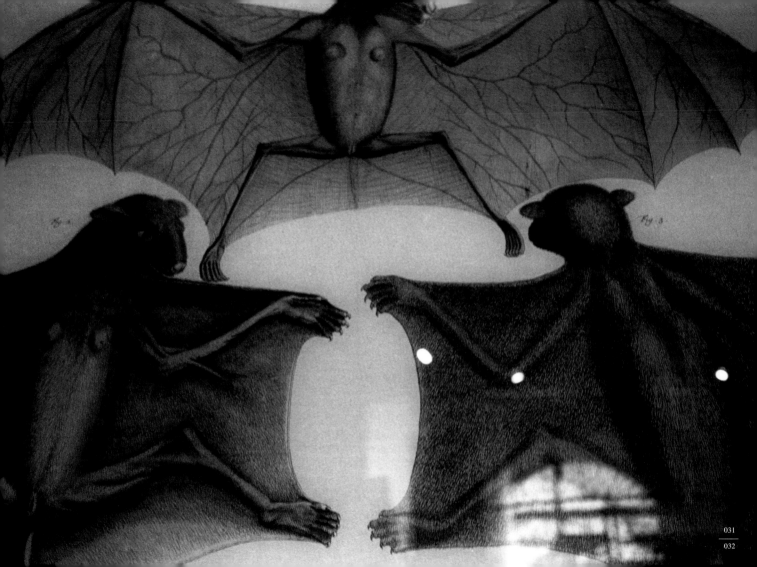

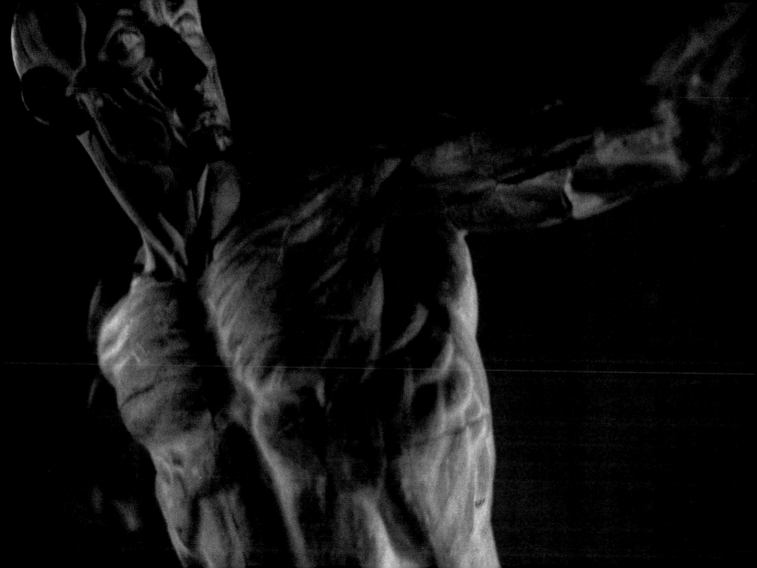

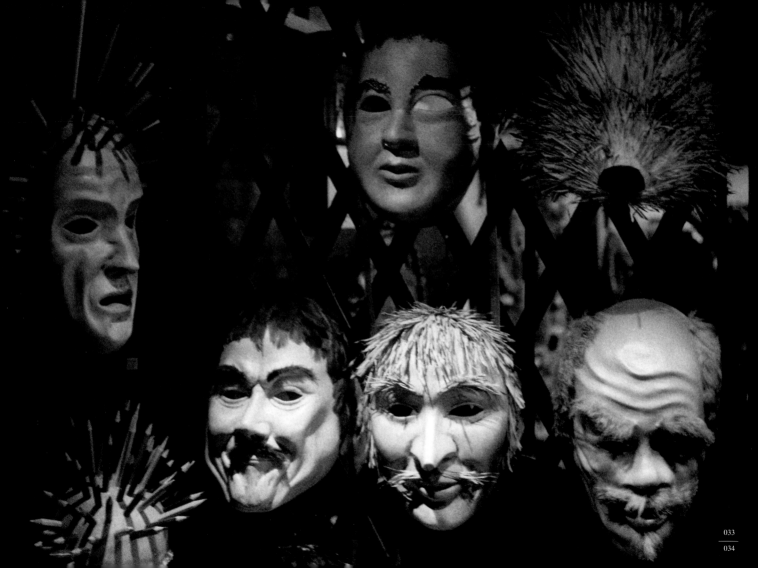

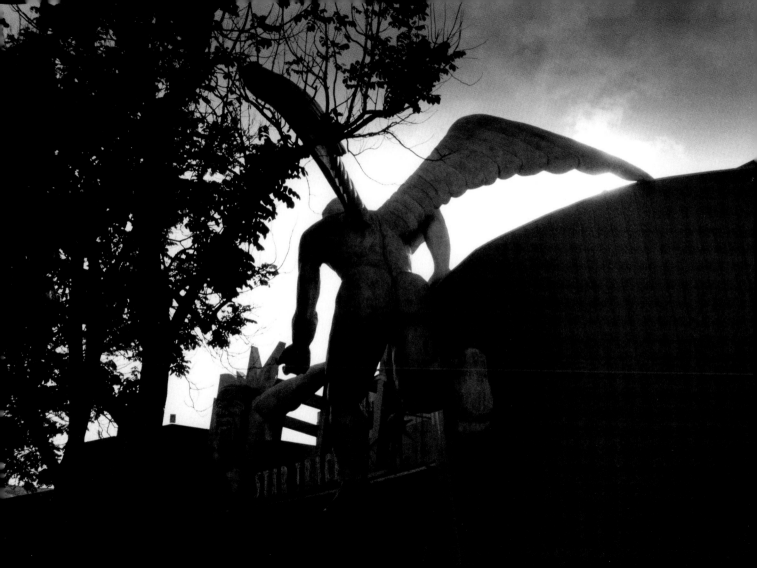

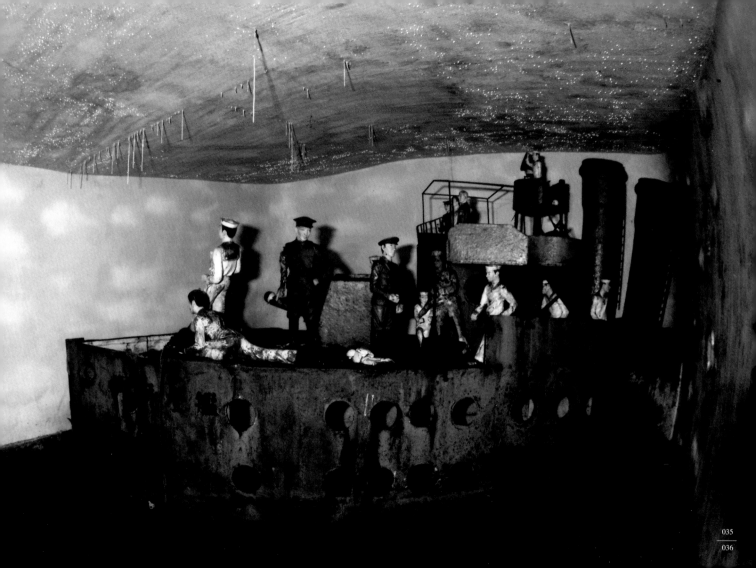

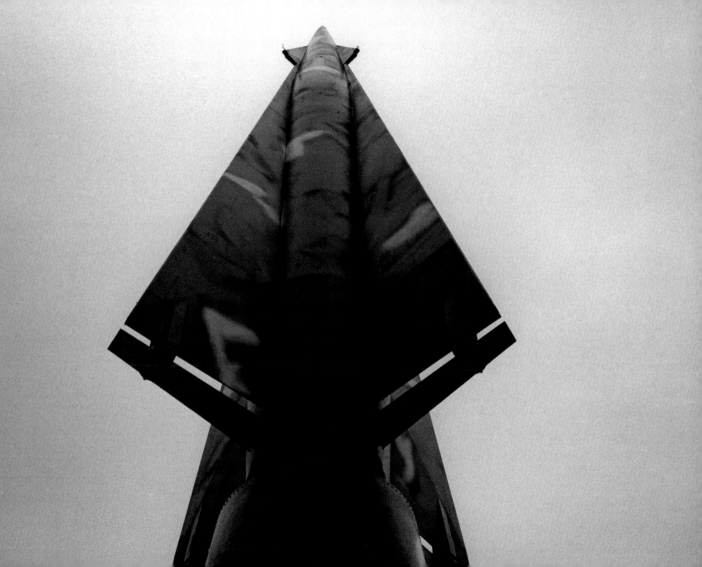

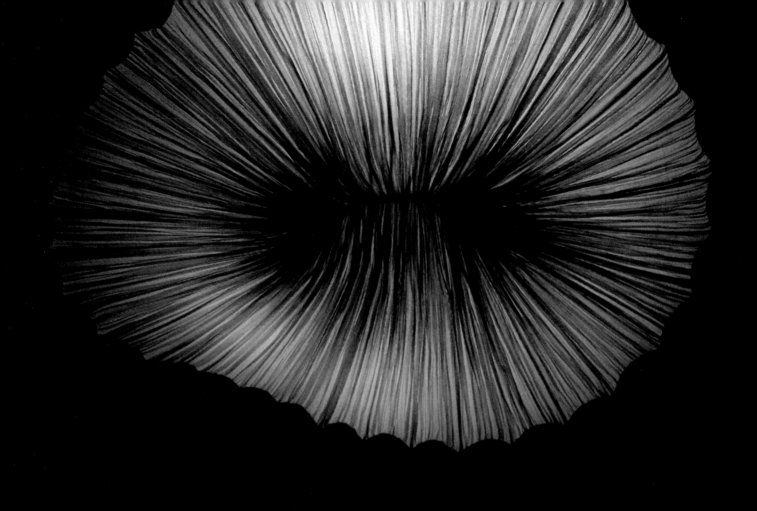

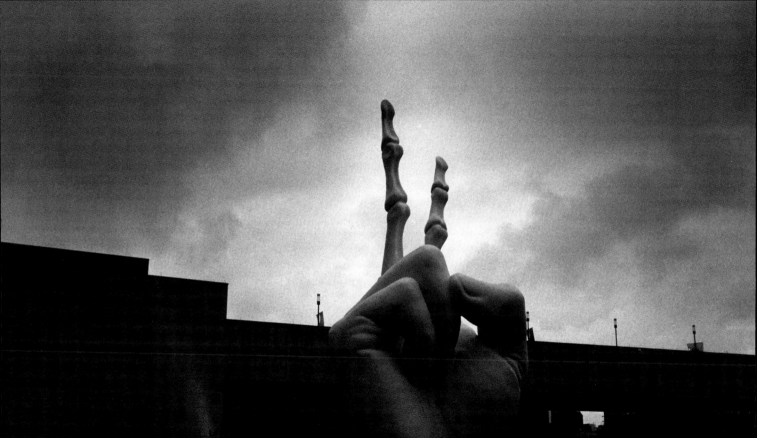

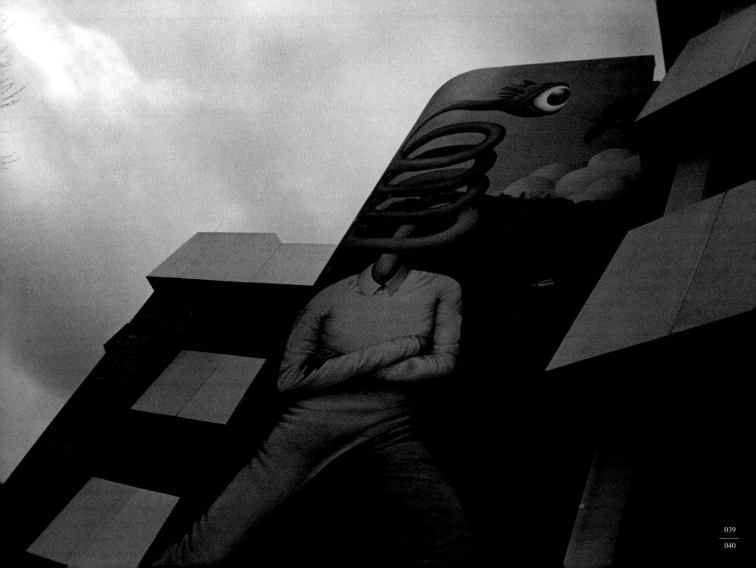

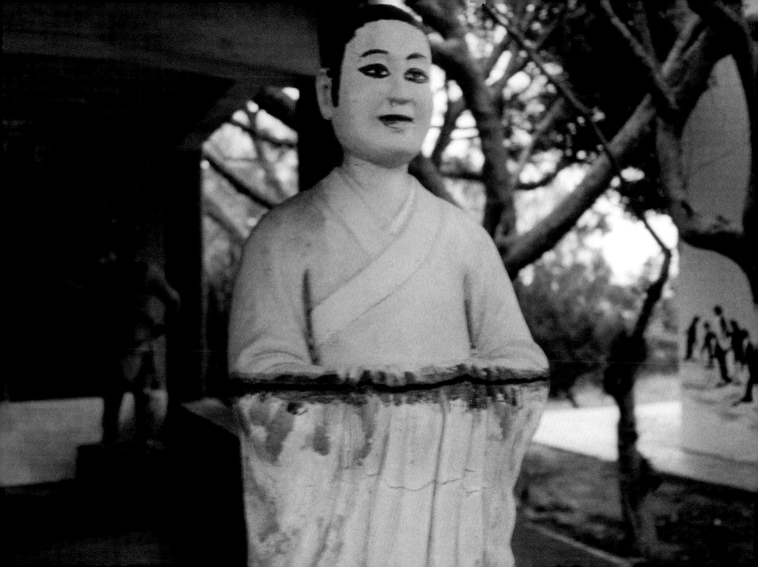

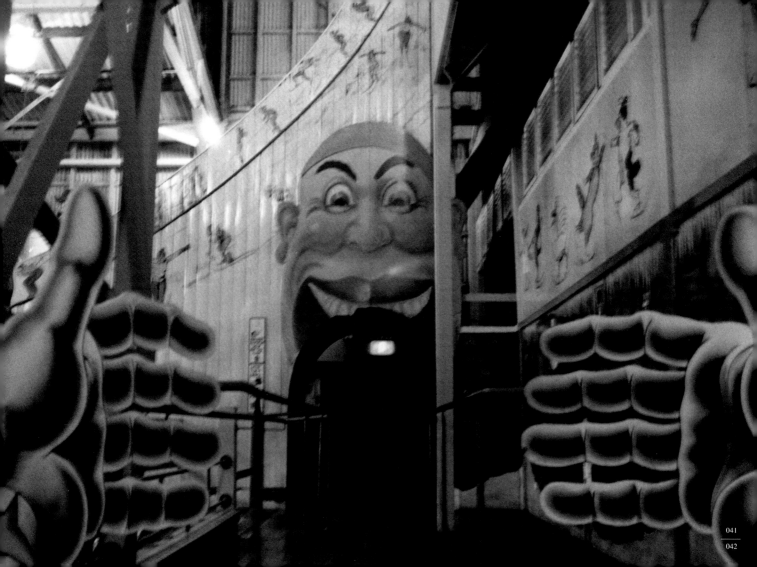

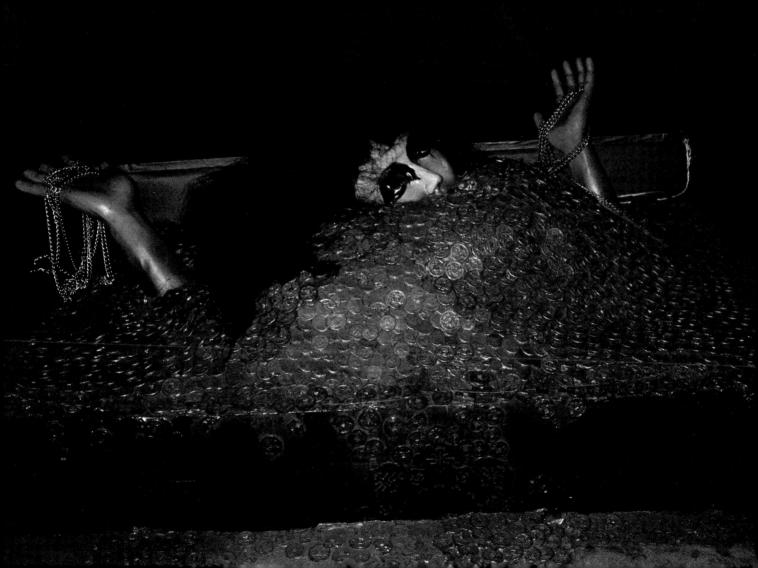

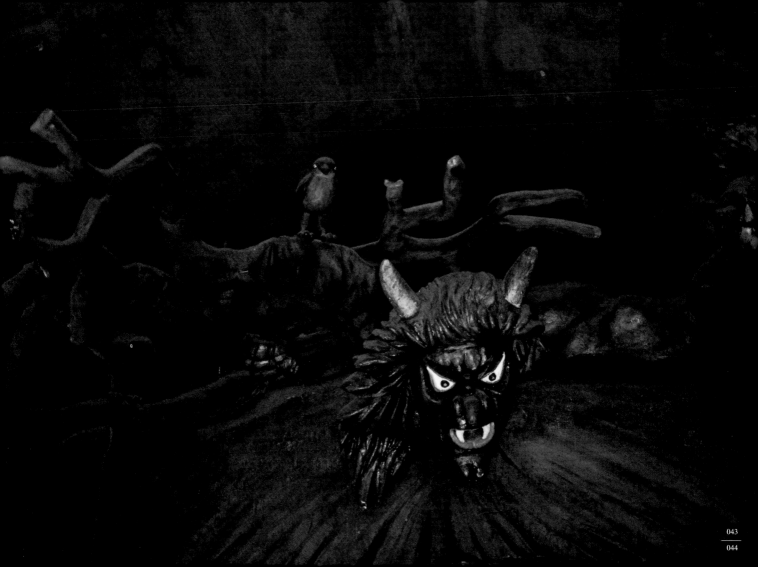

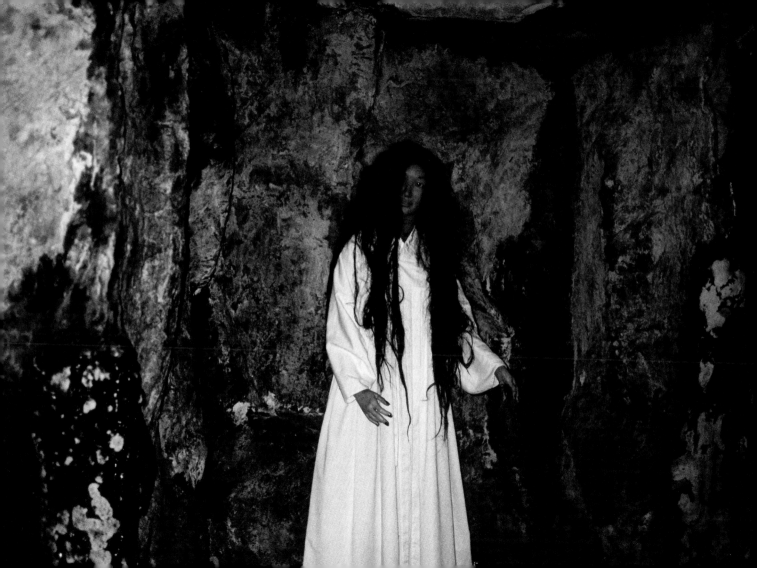

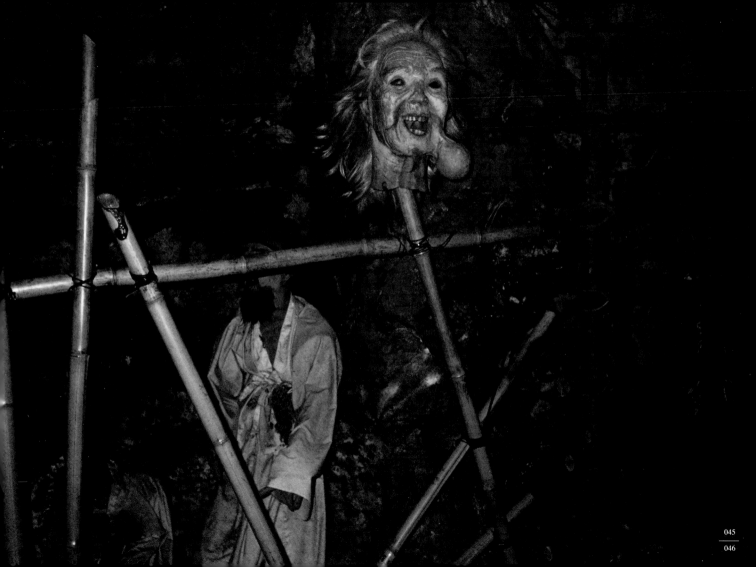

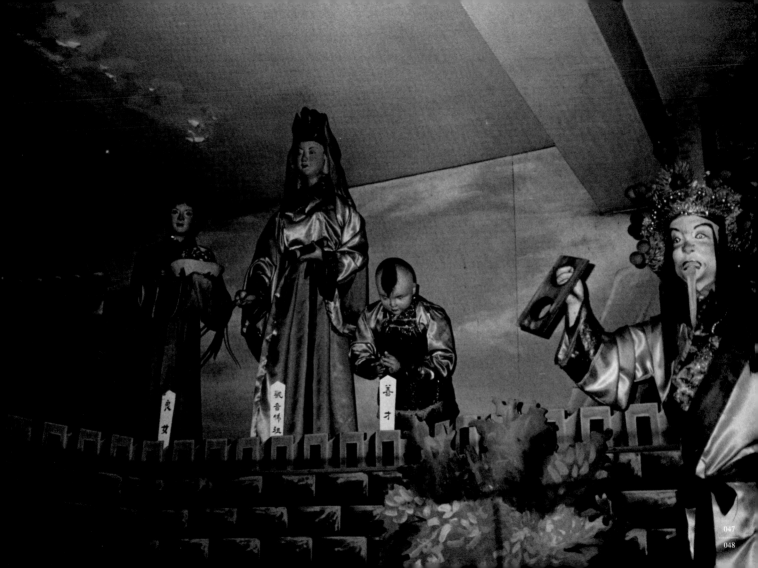

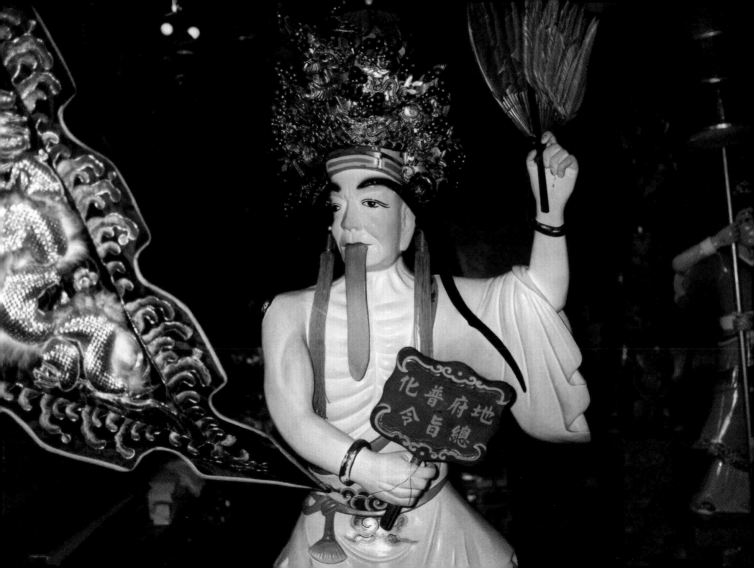

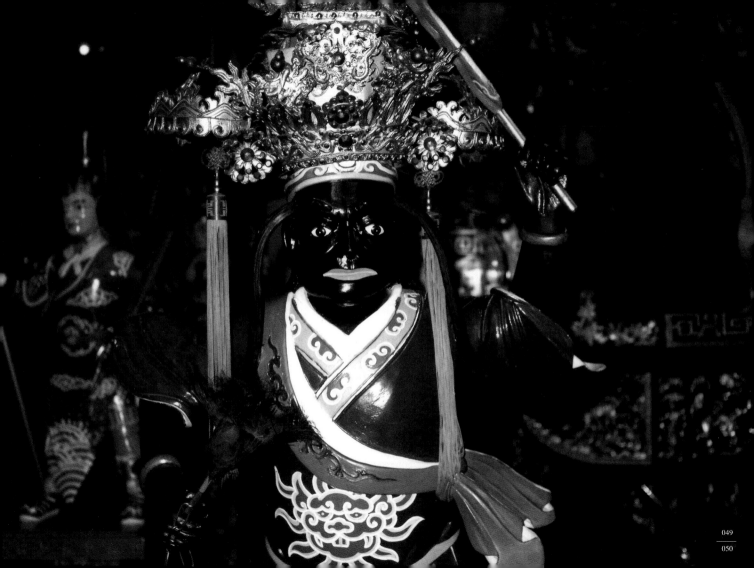

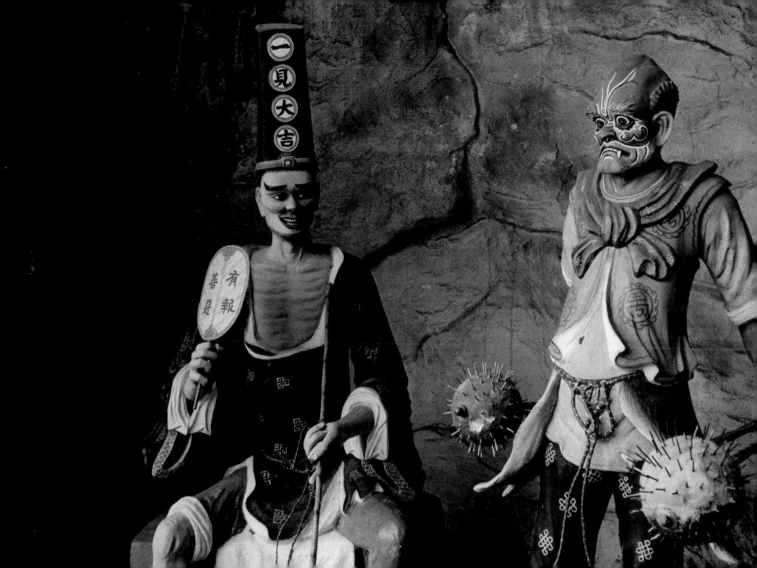

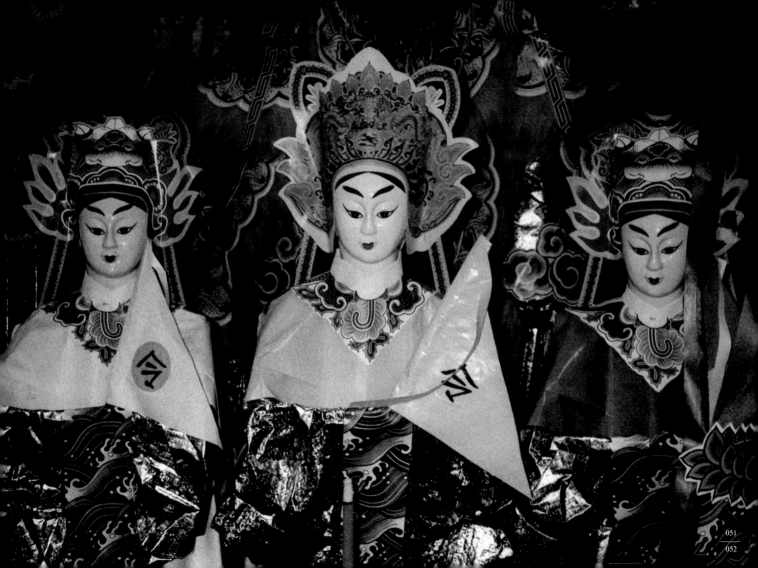

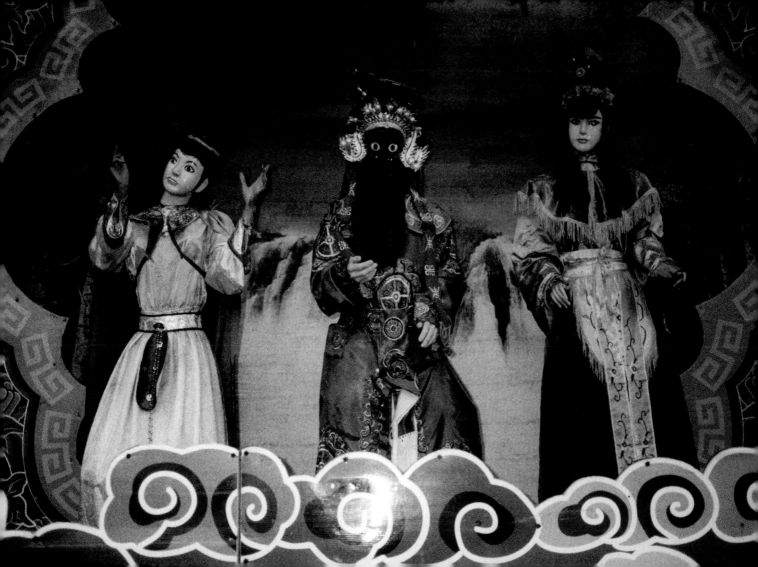

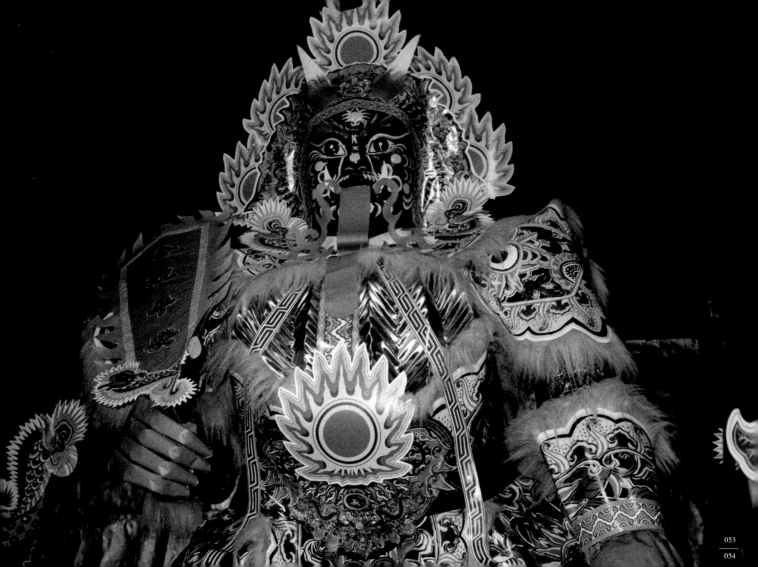

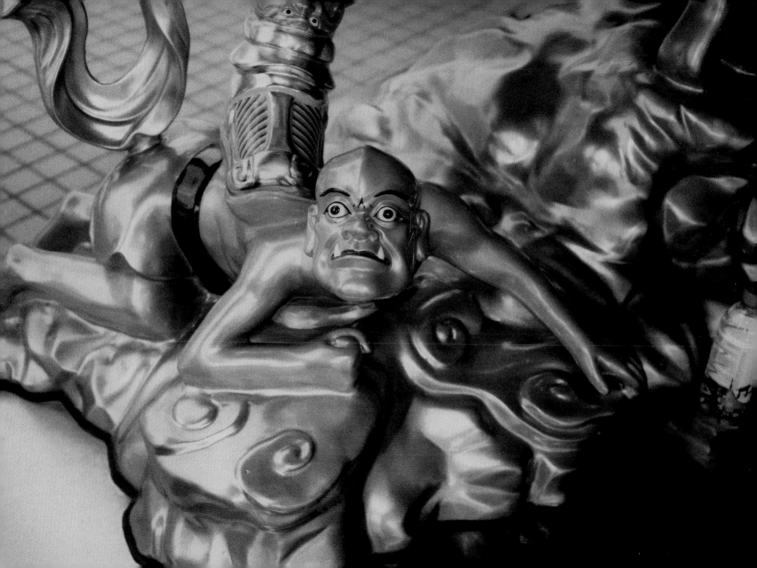

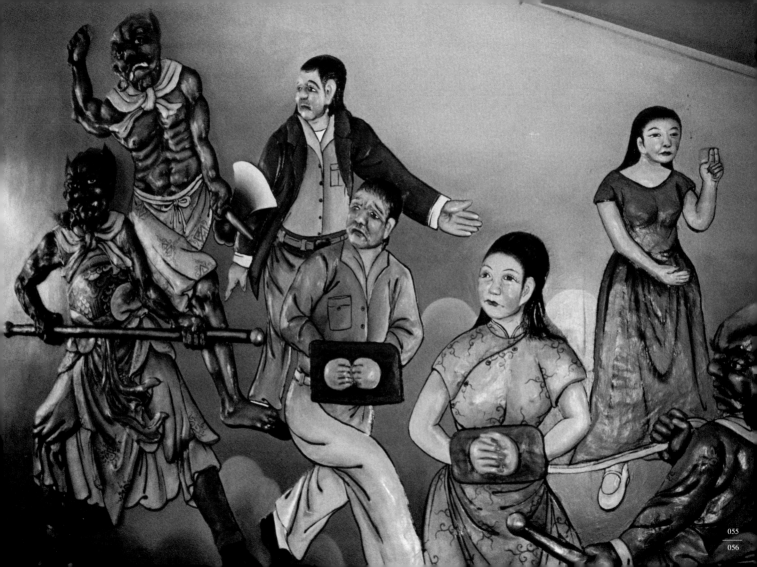

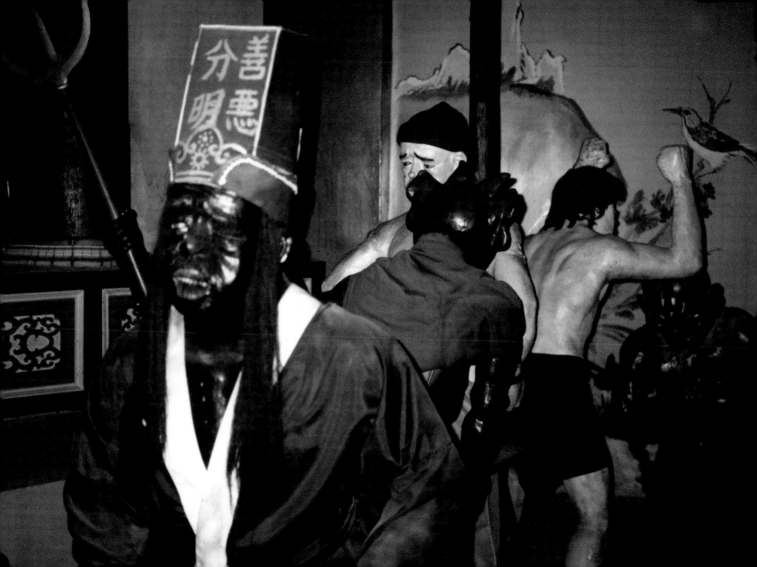

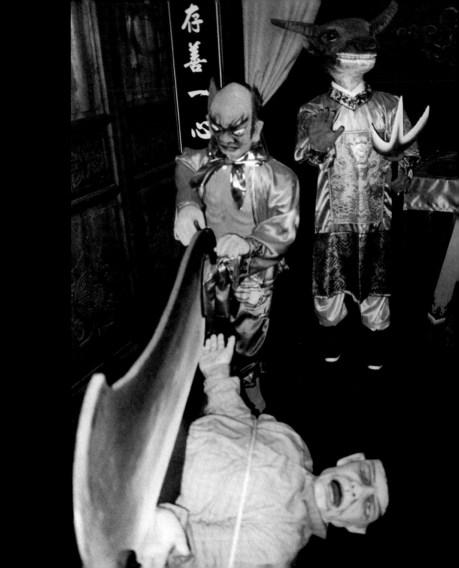

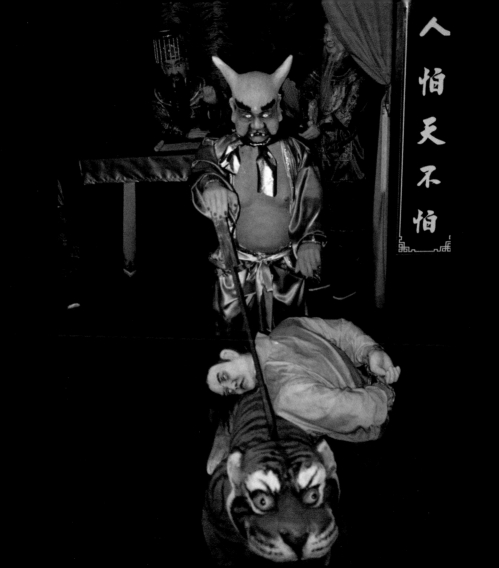

人怕天不怕

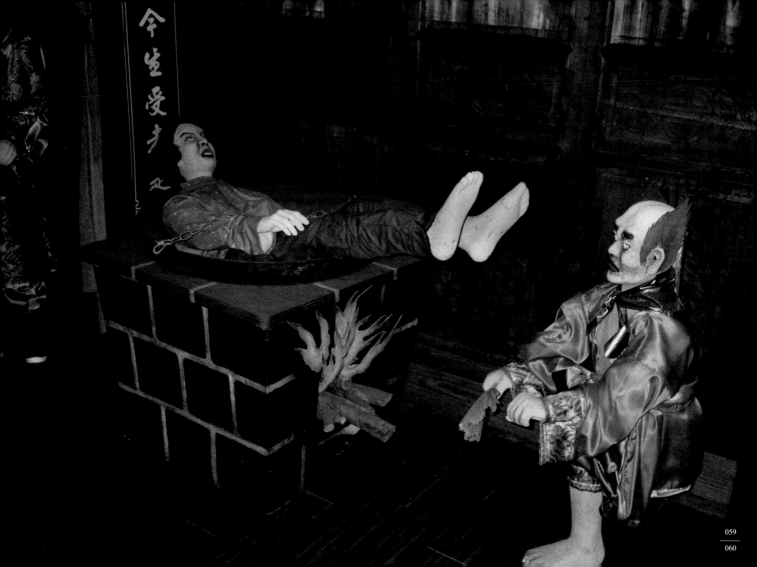

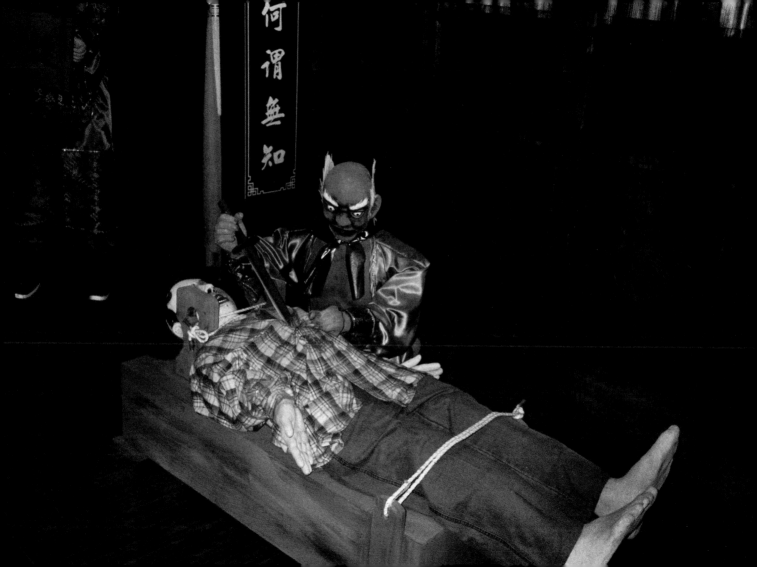

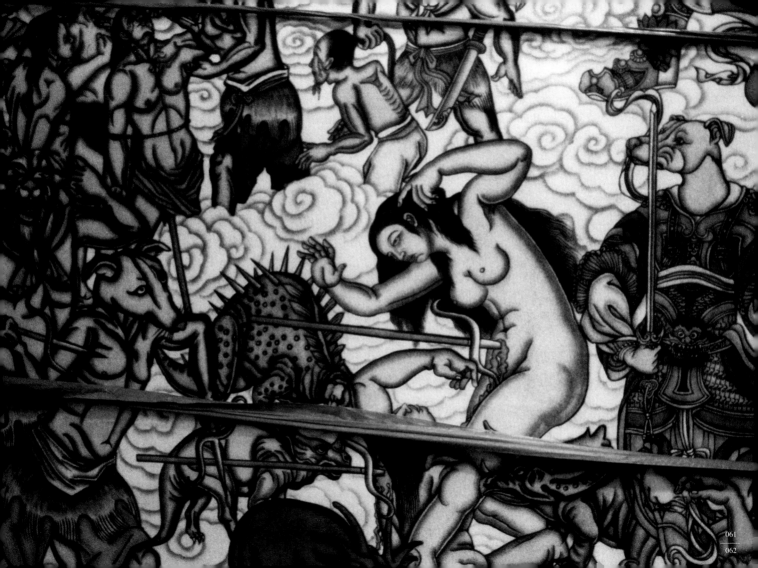

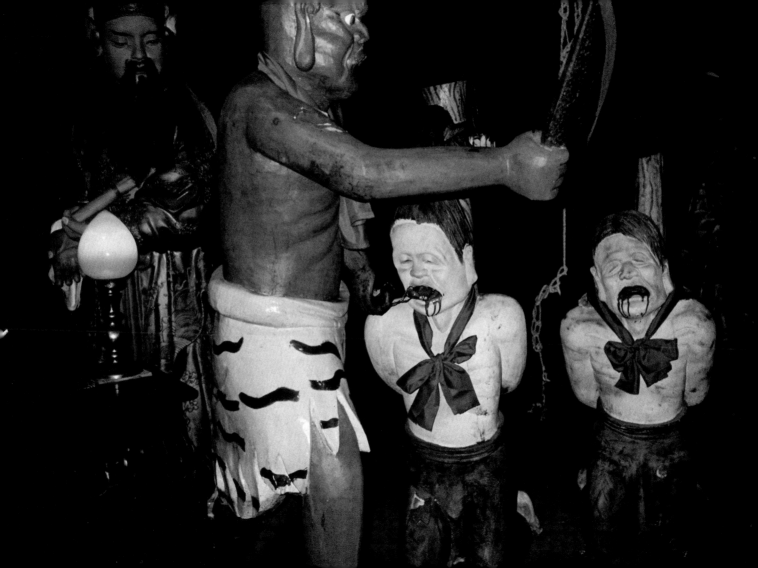

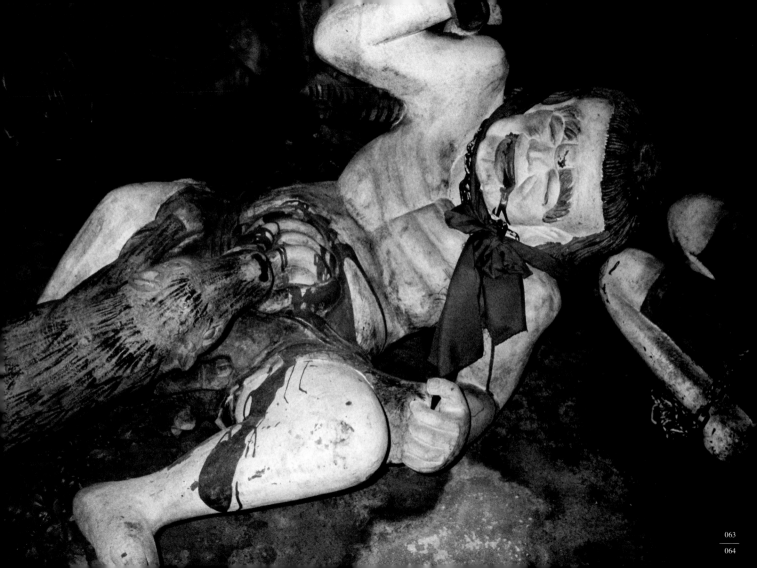

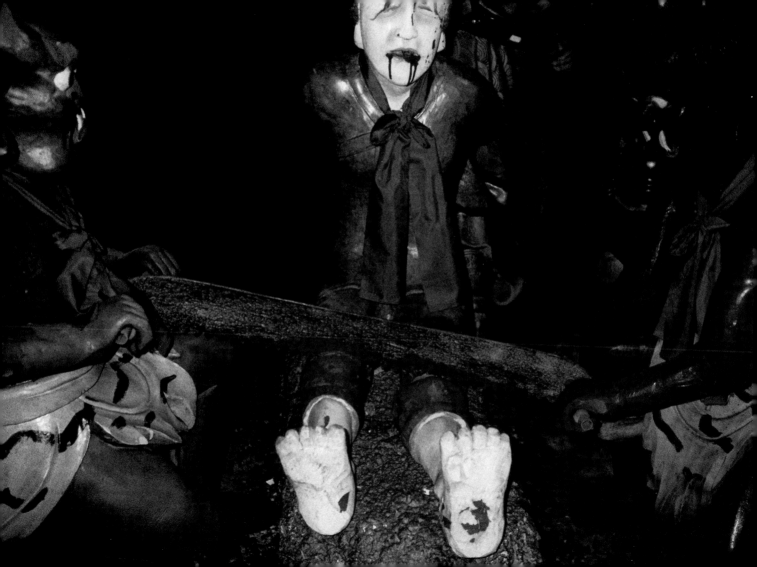

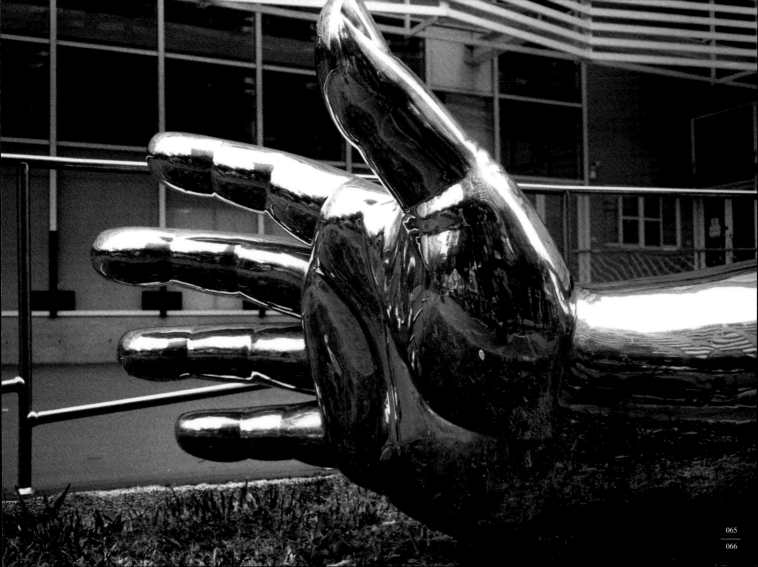

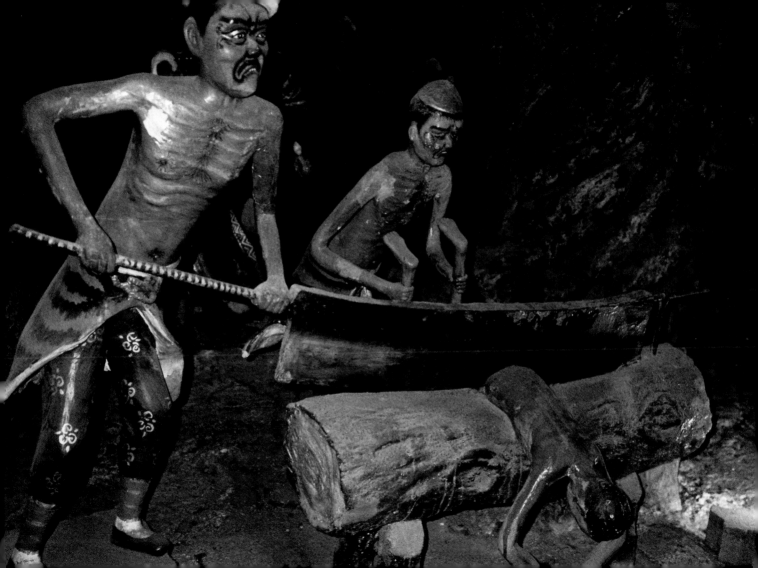

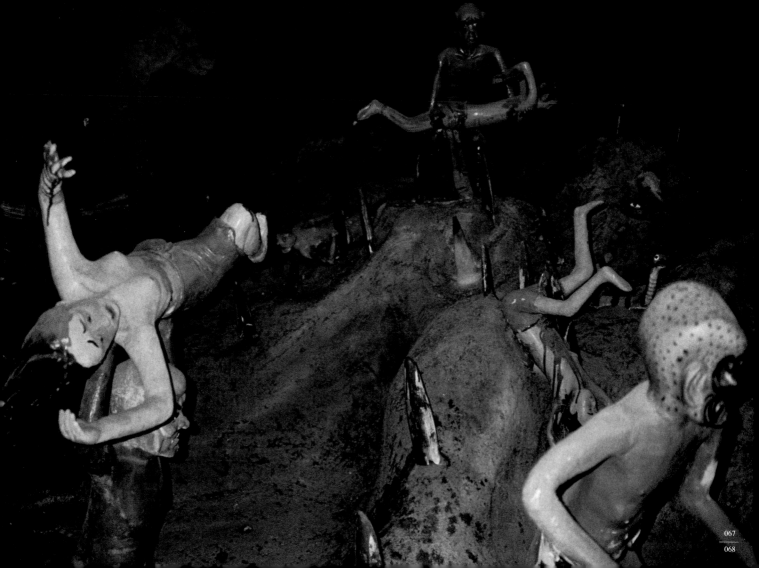

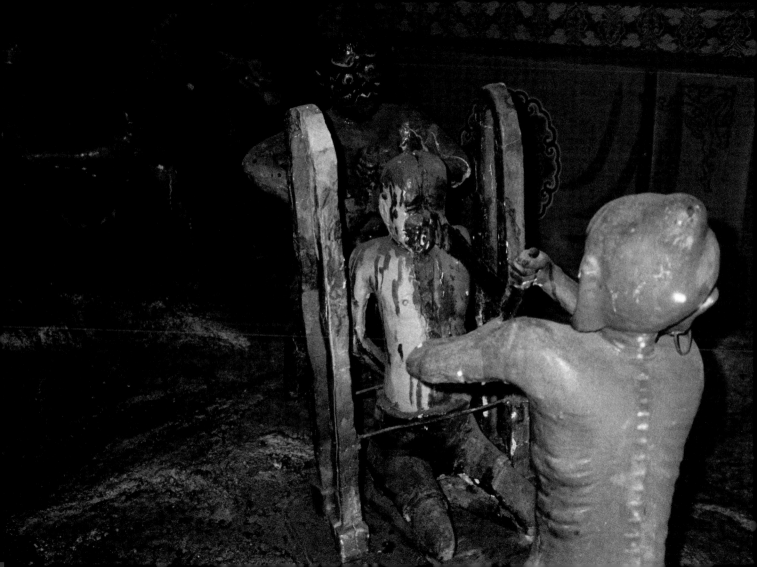

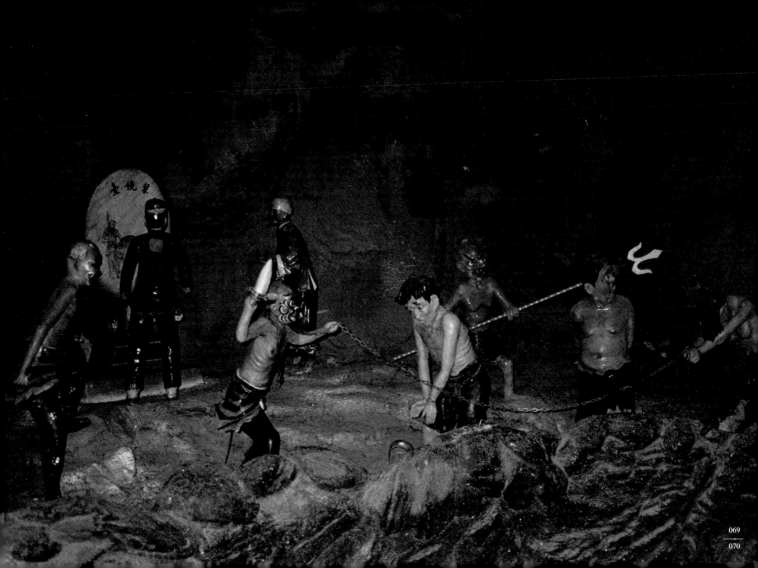

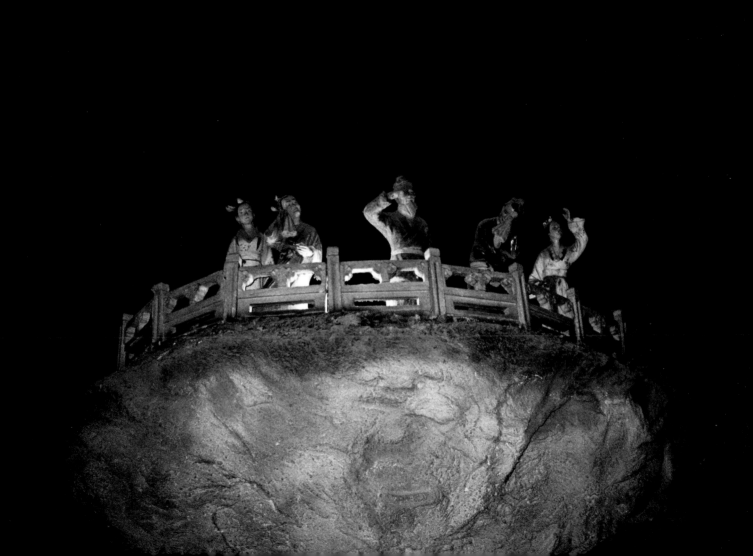

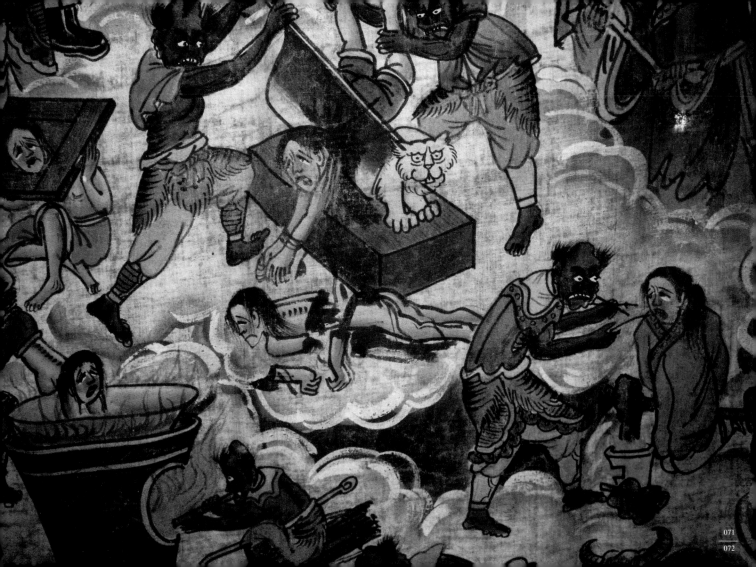

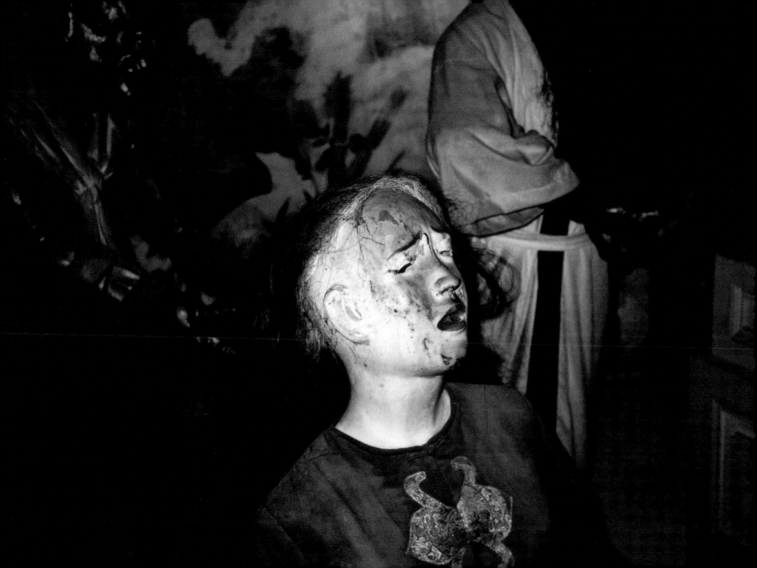

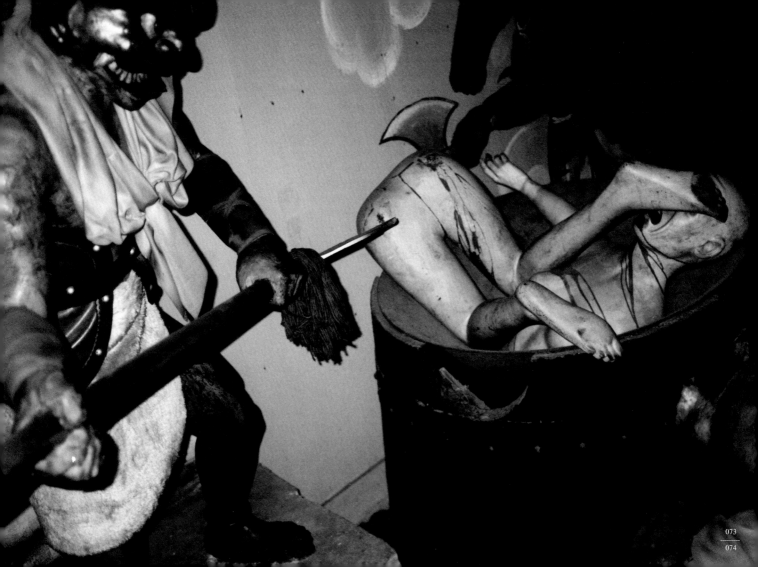

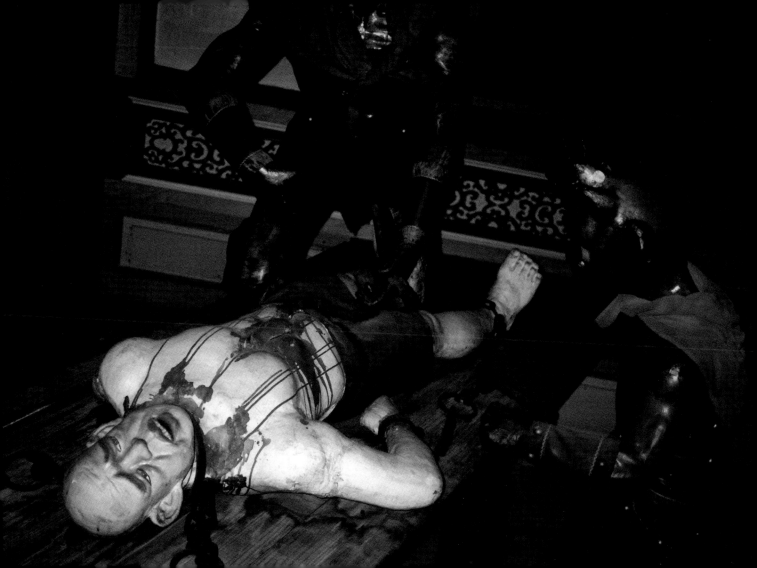

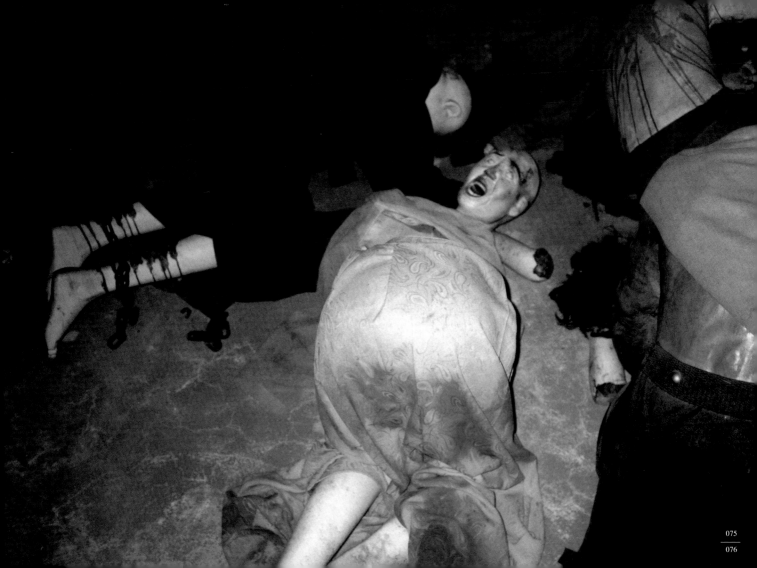

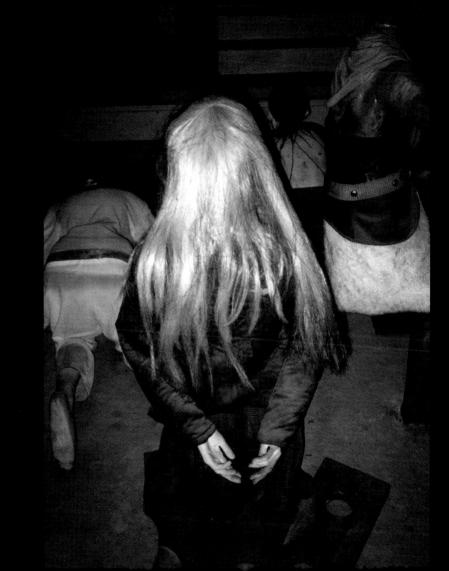

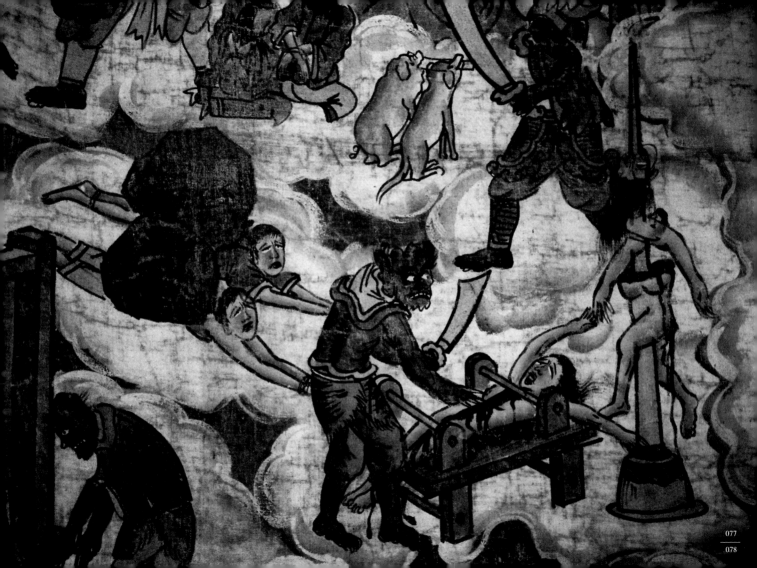

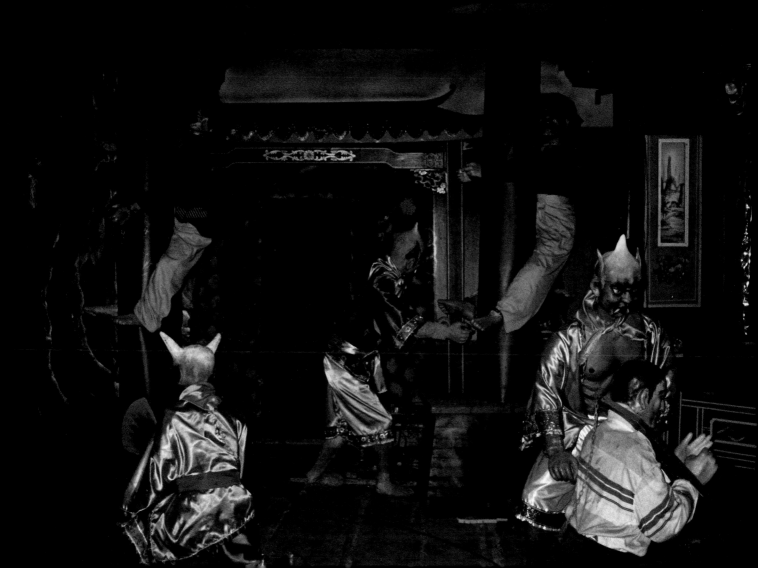

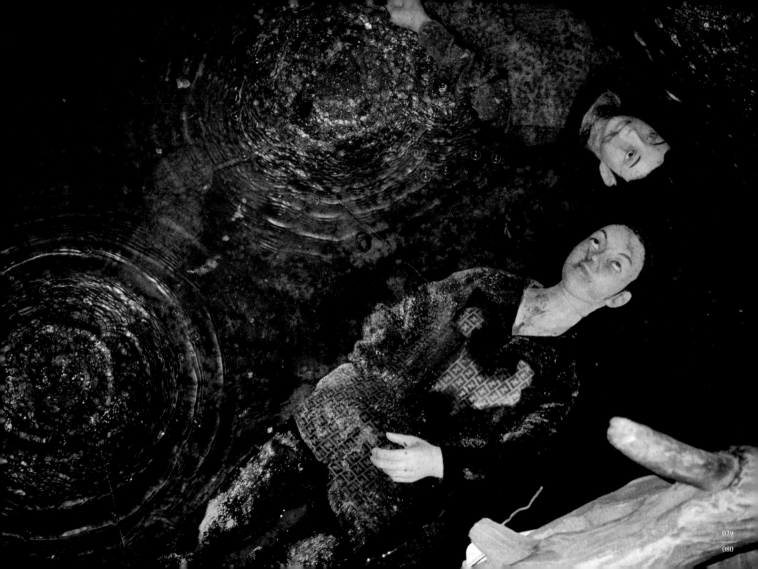

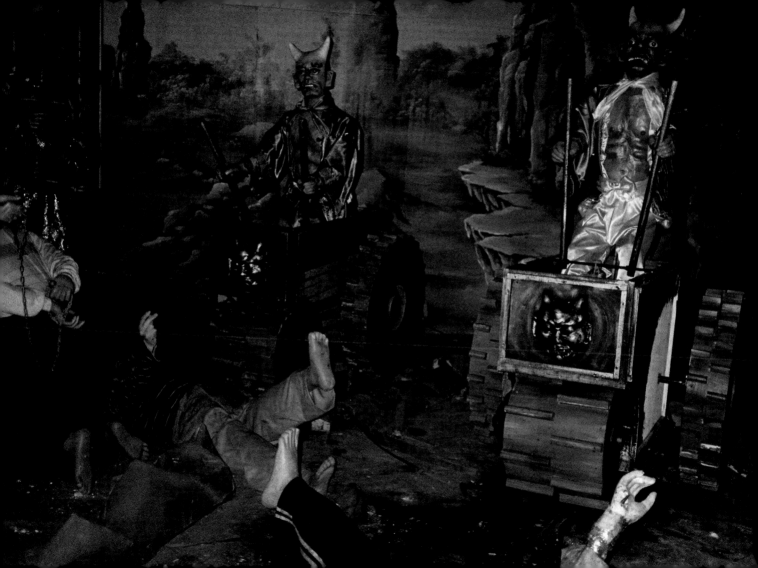

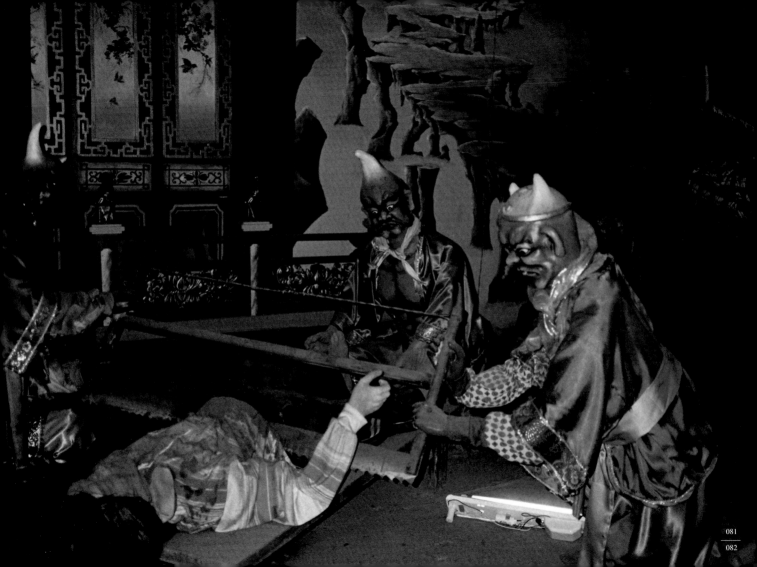

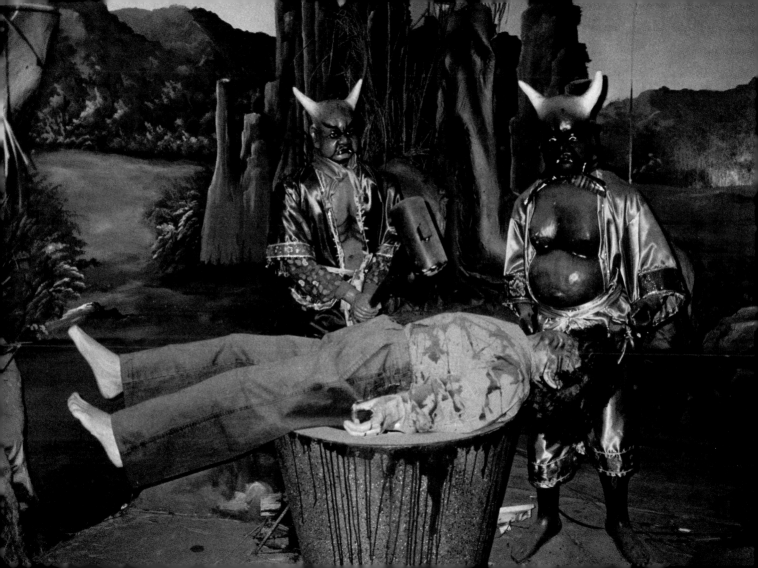

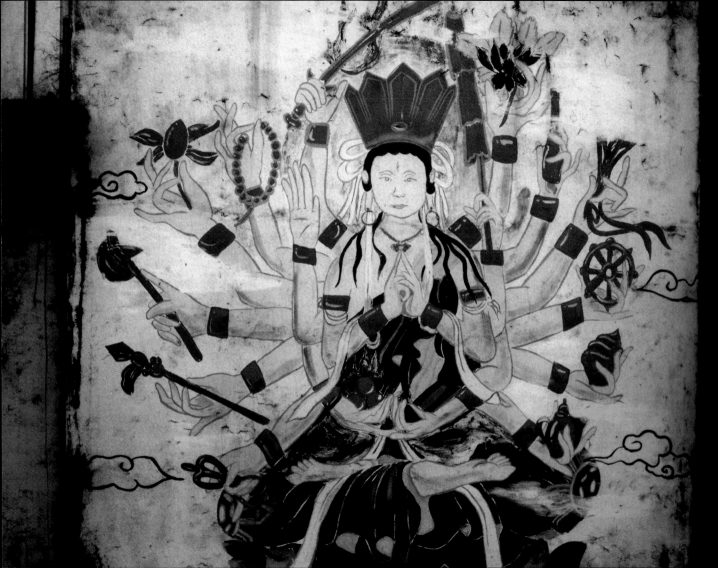

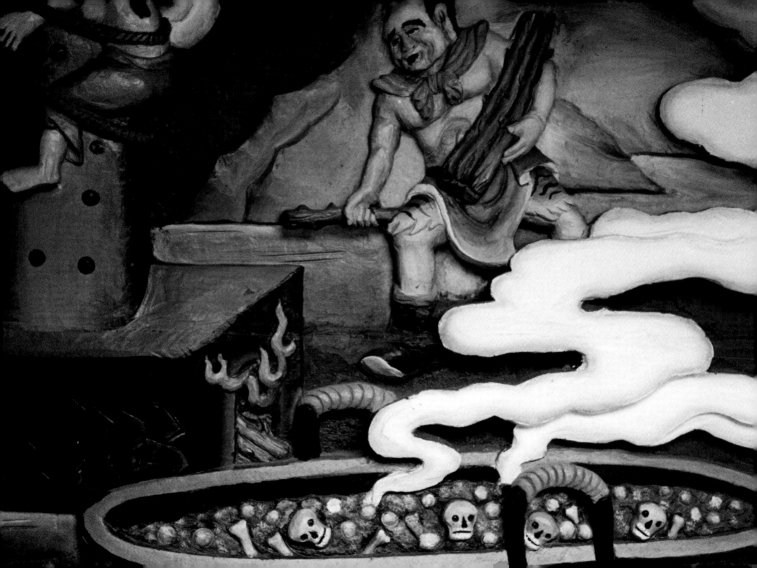

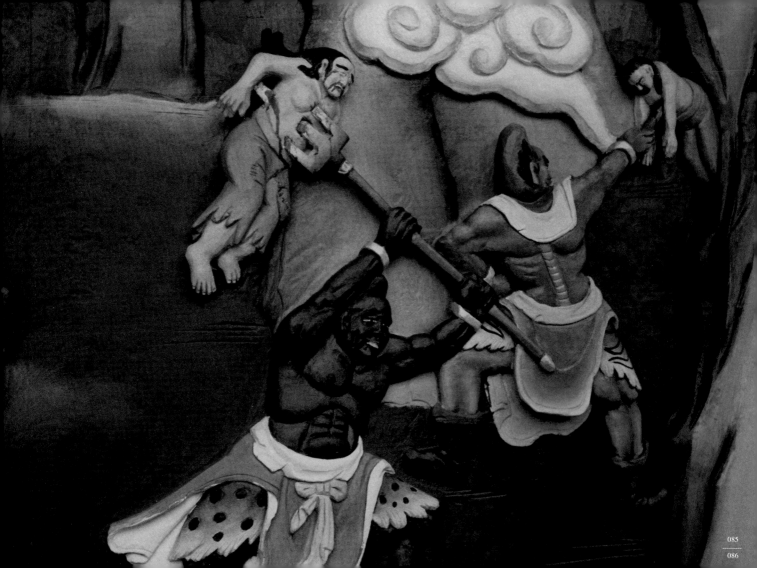

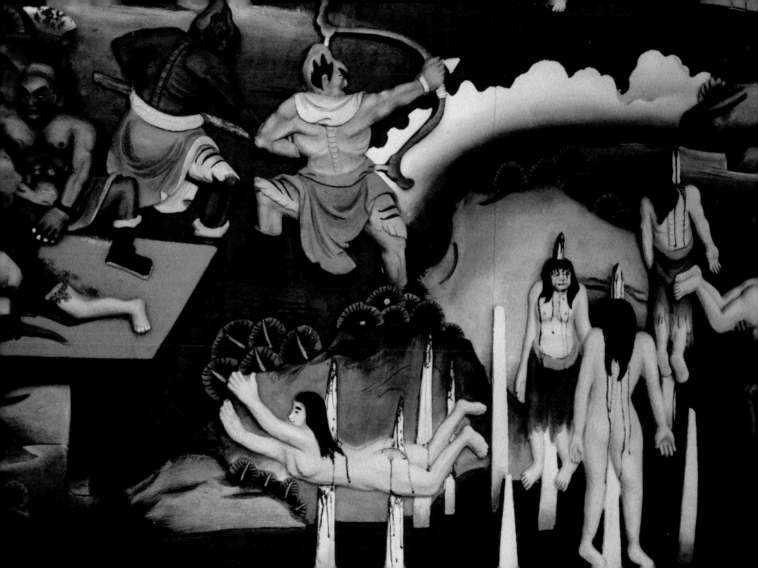

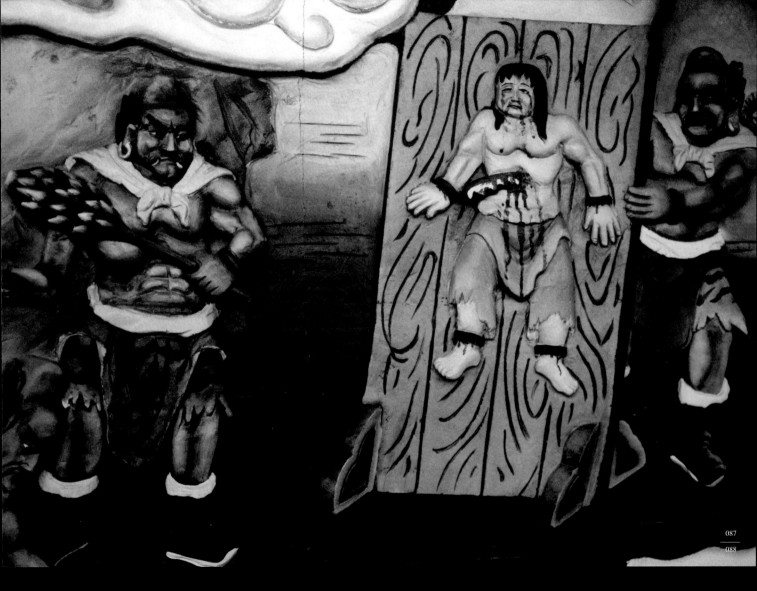

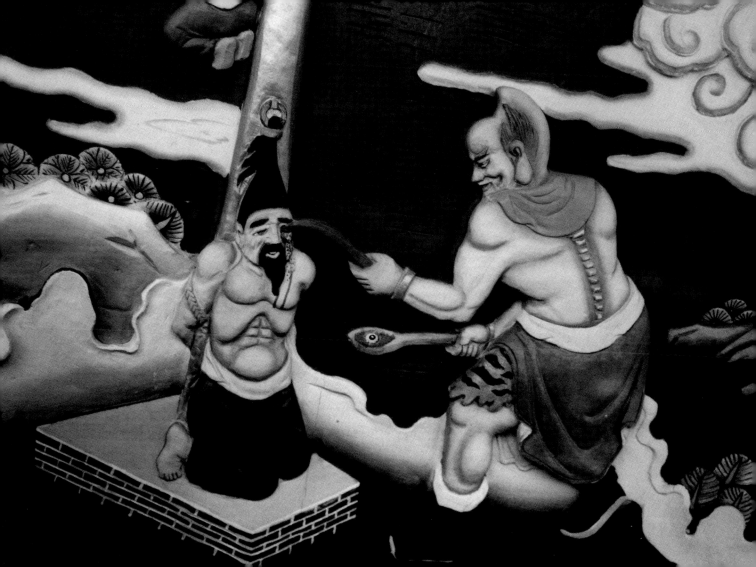

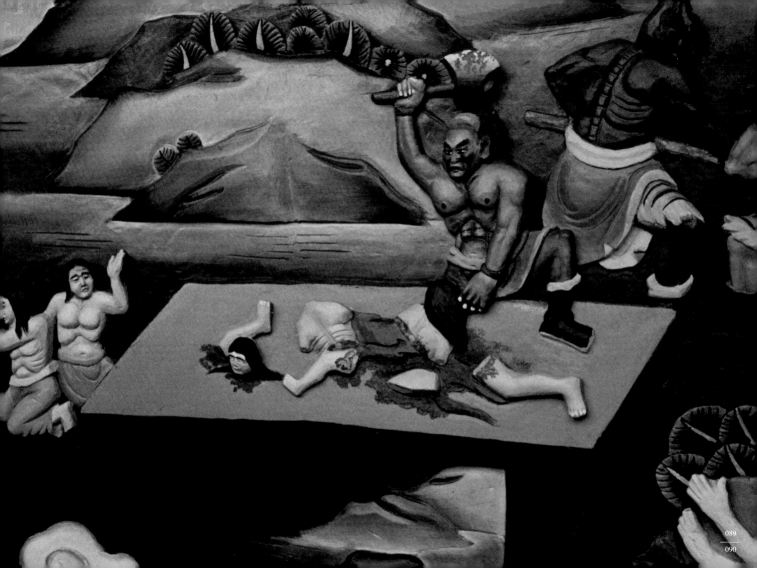

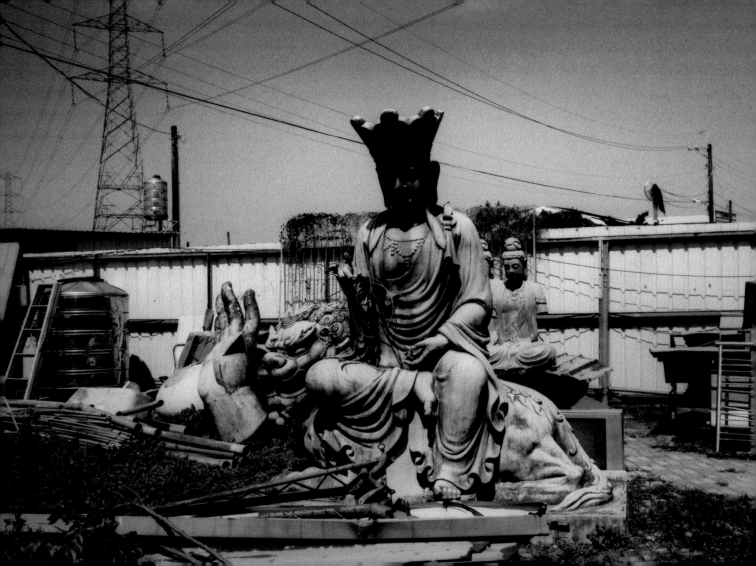

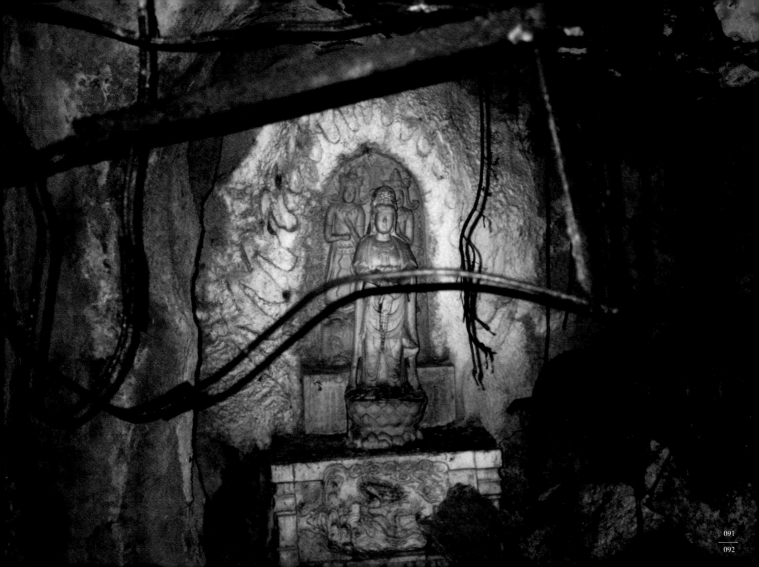

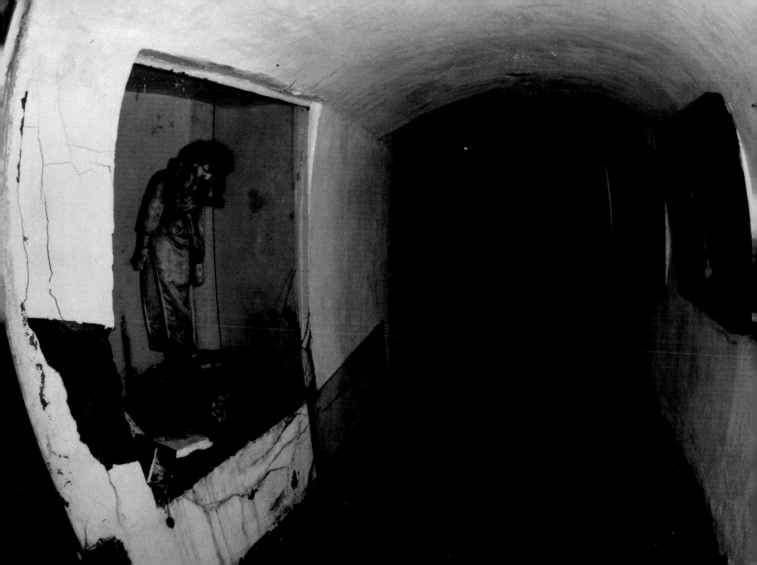

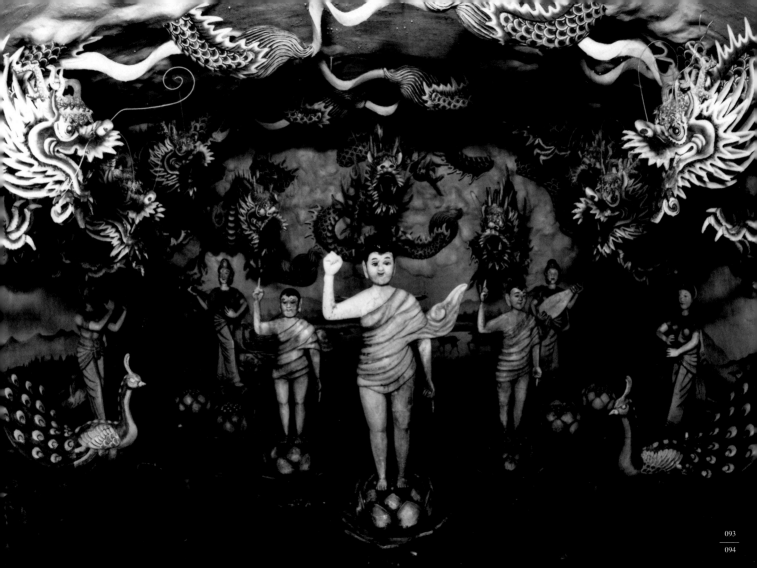

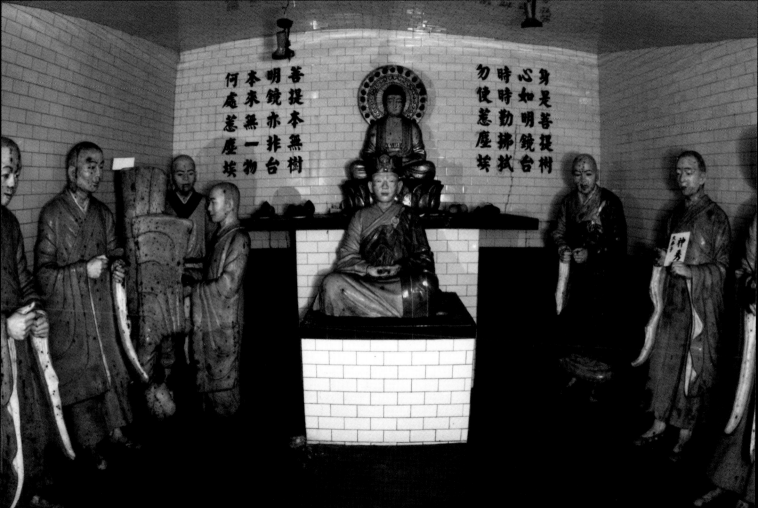

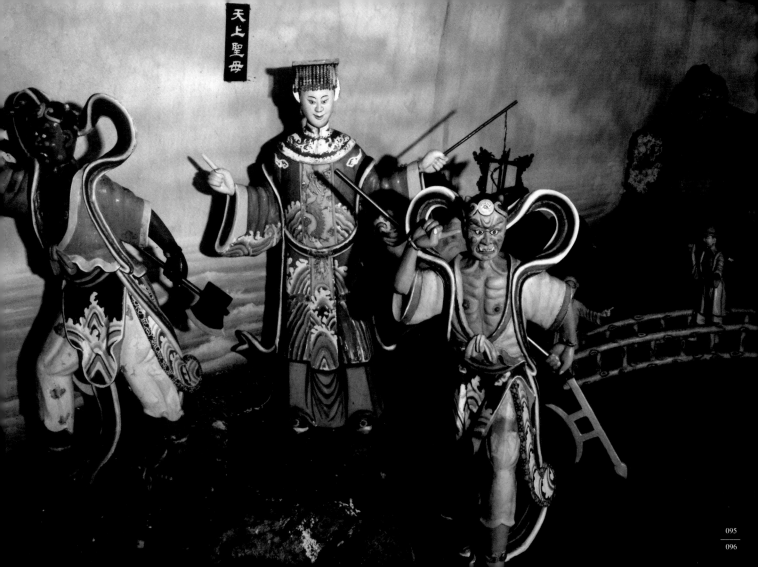

天上聖母

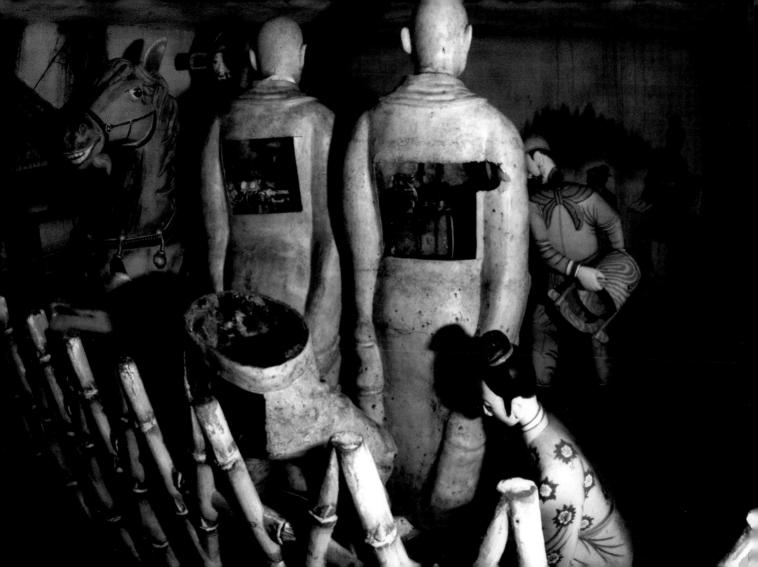

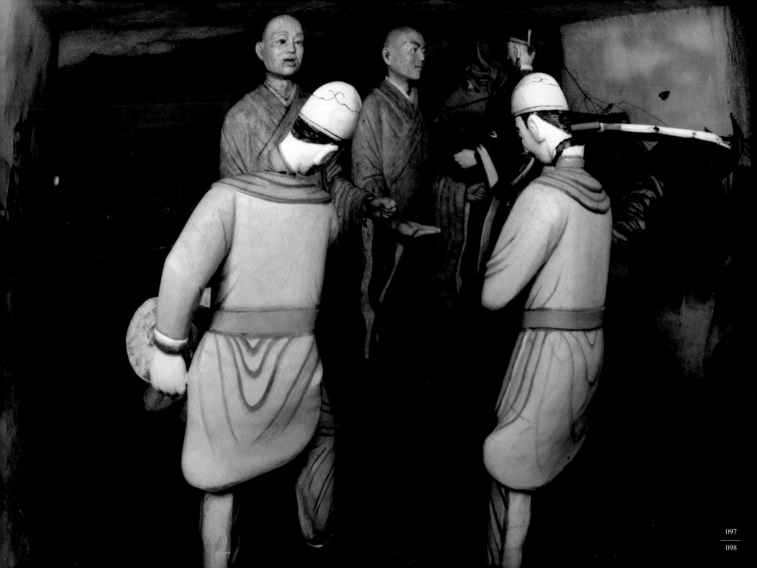

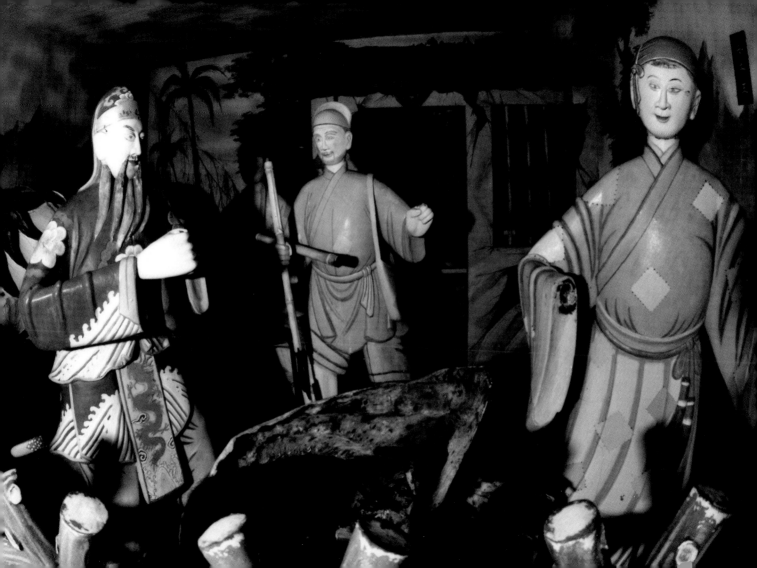

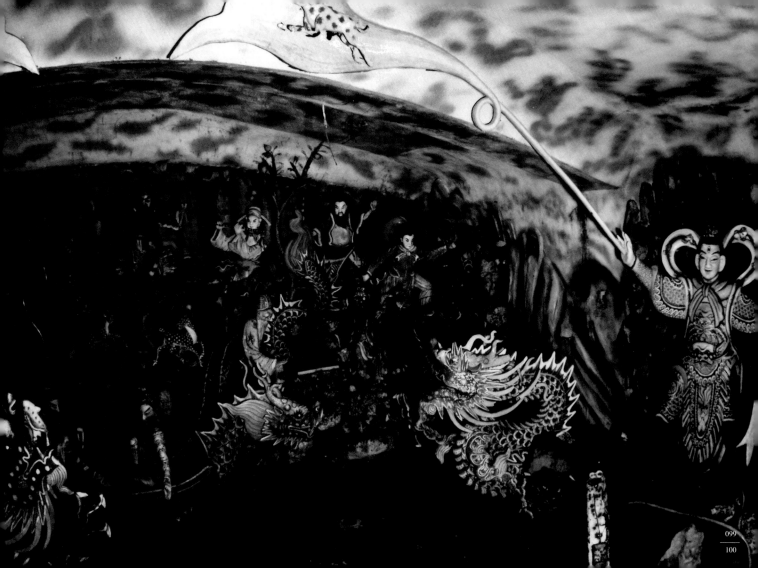

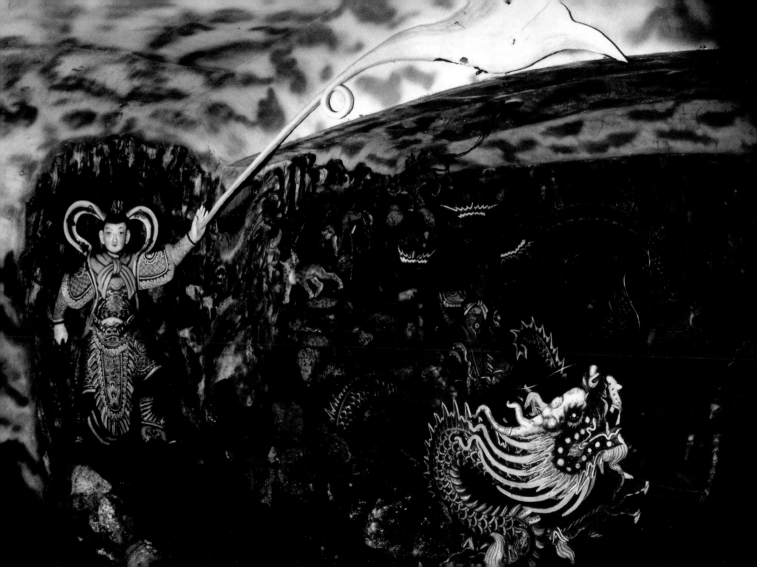

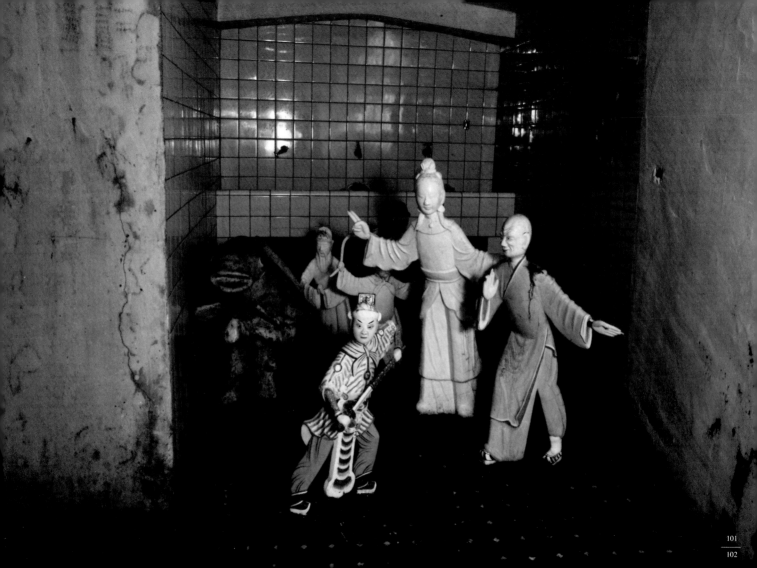

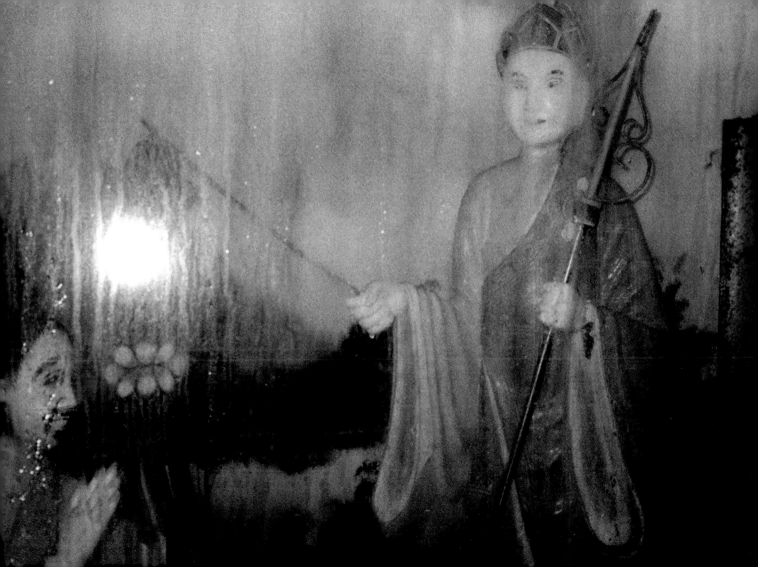

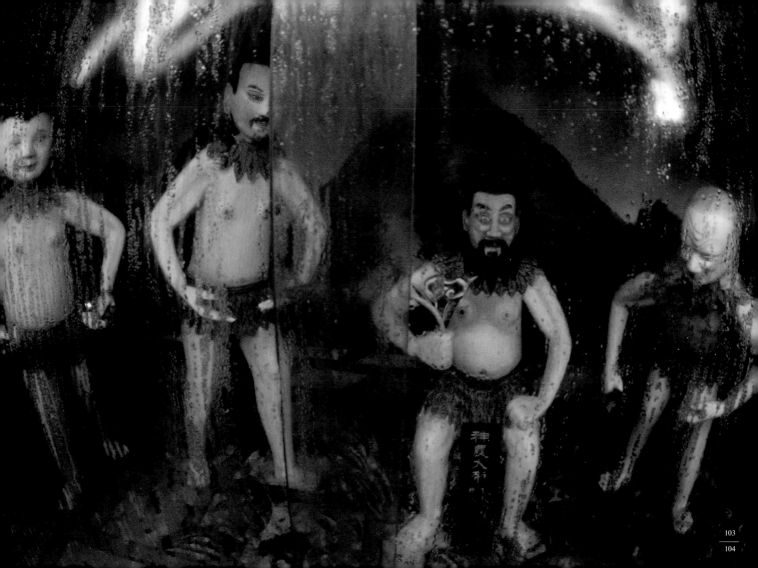

103
104

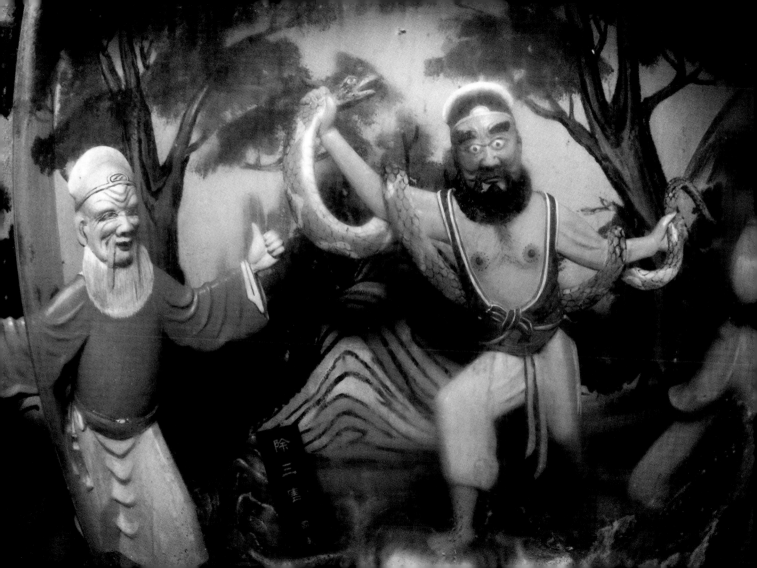

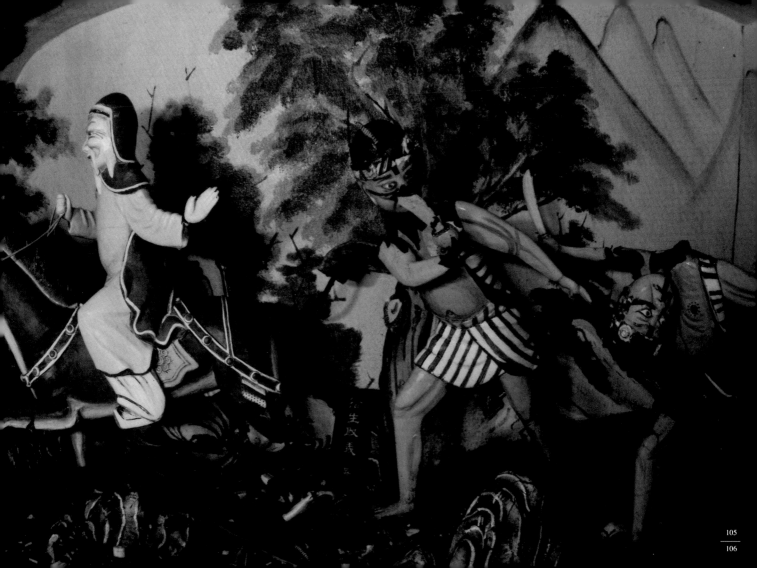

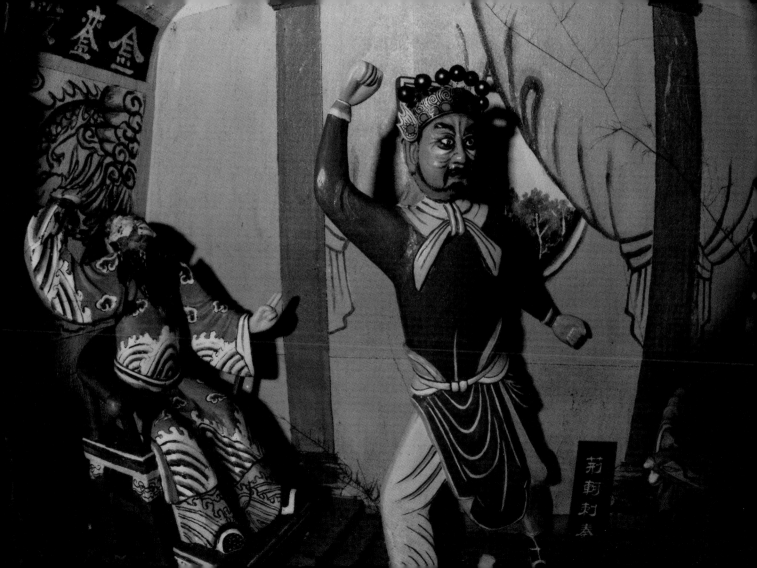

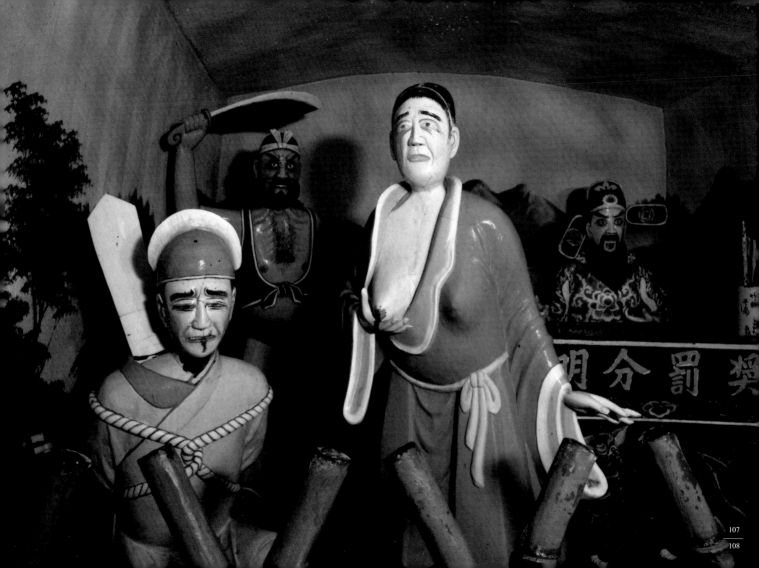

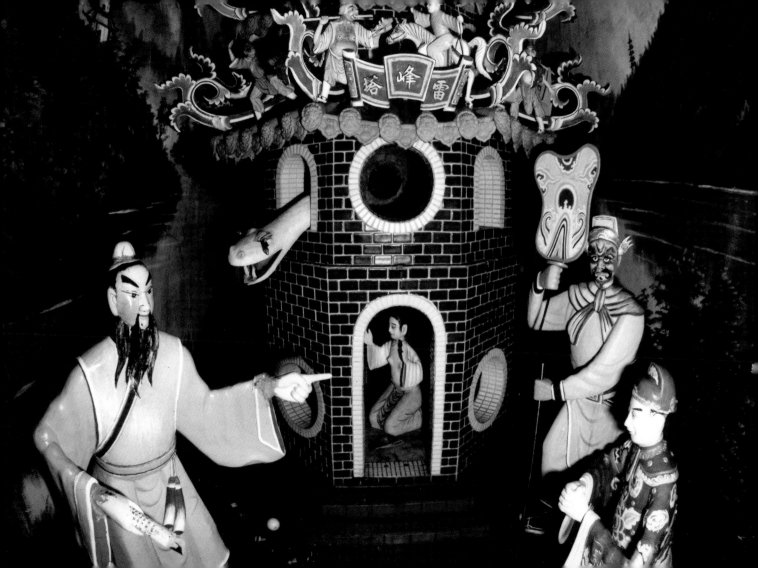

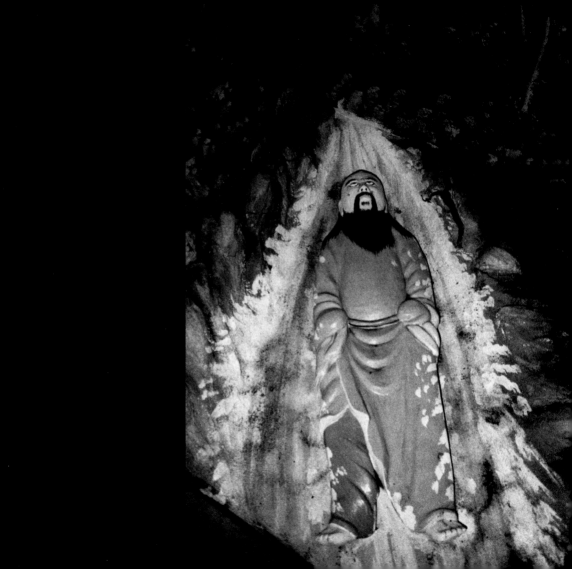

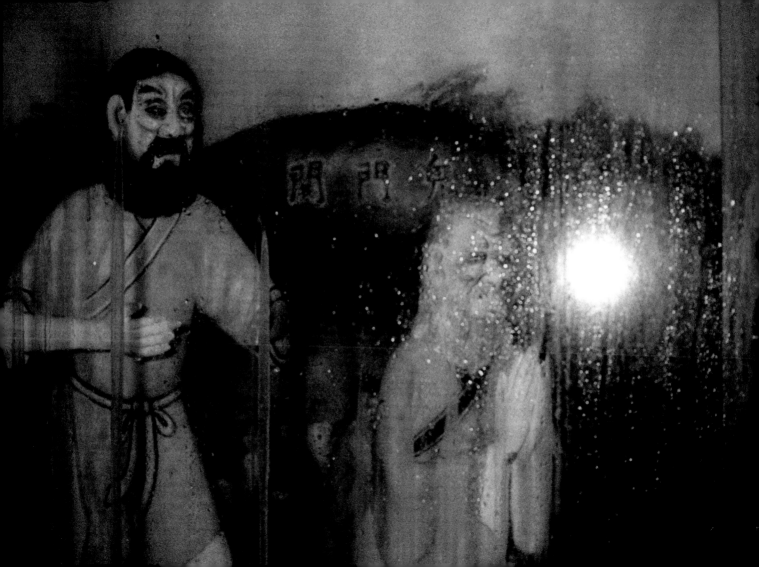

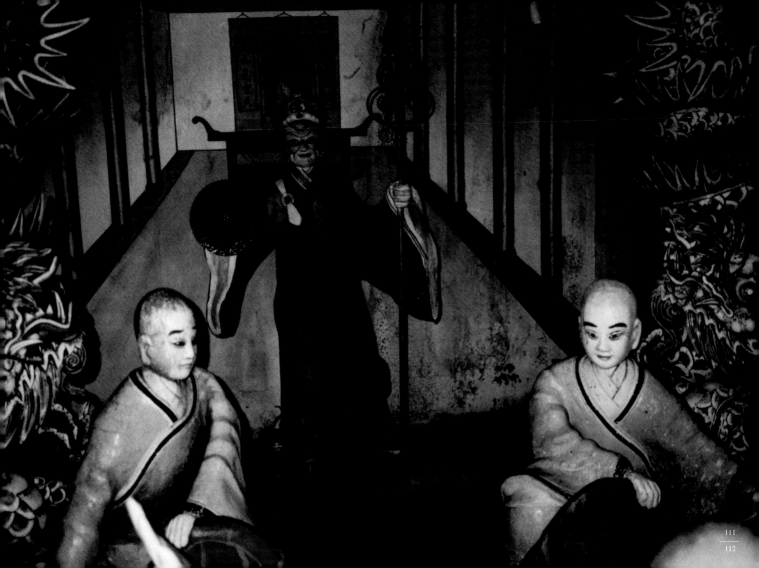

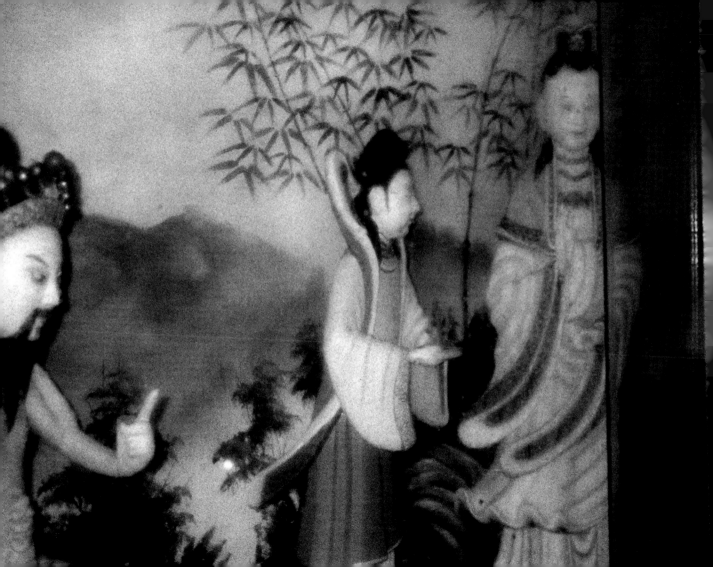

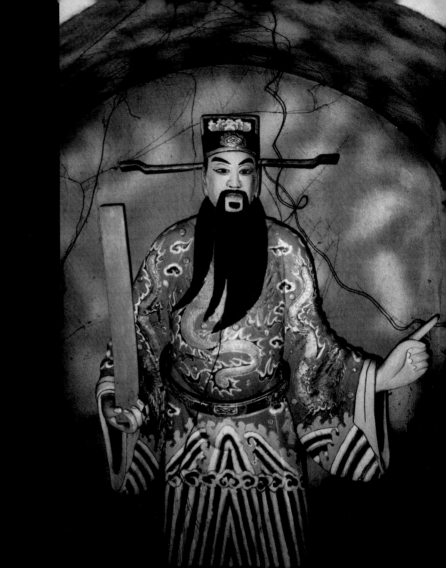

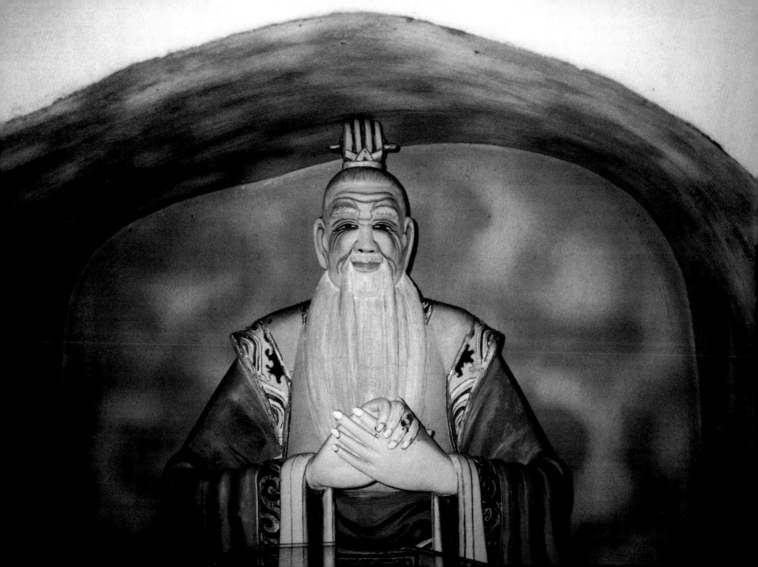

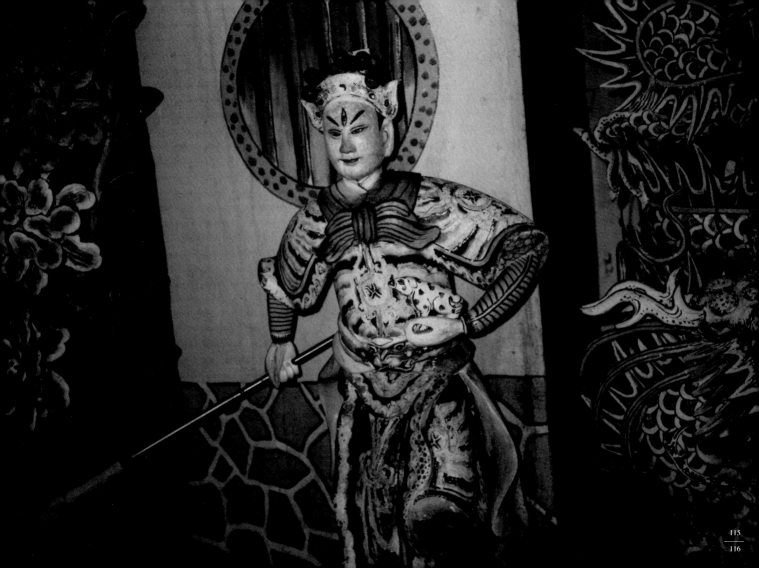

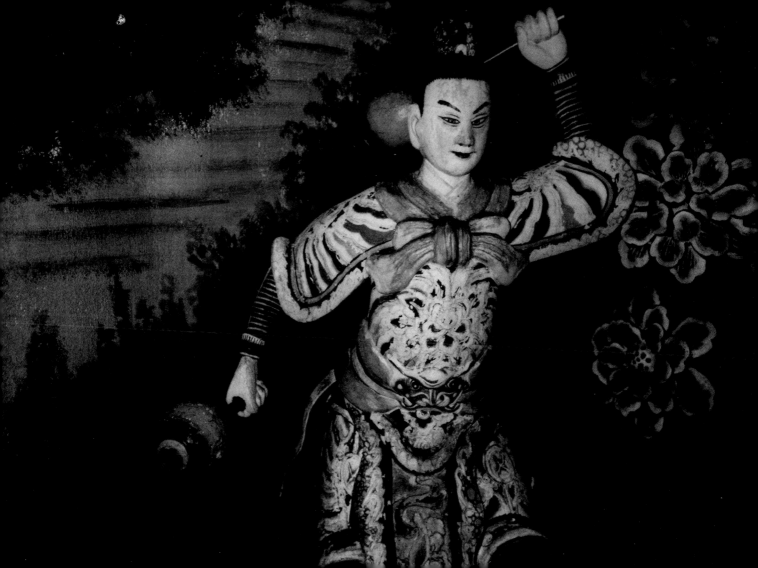

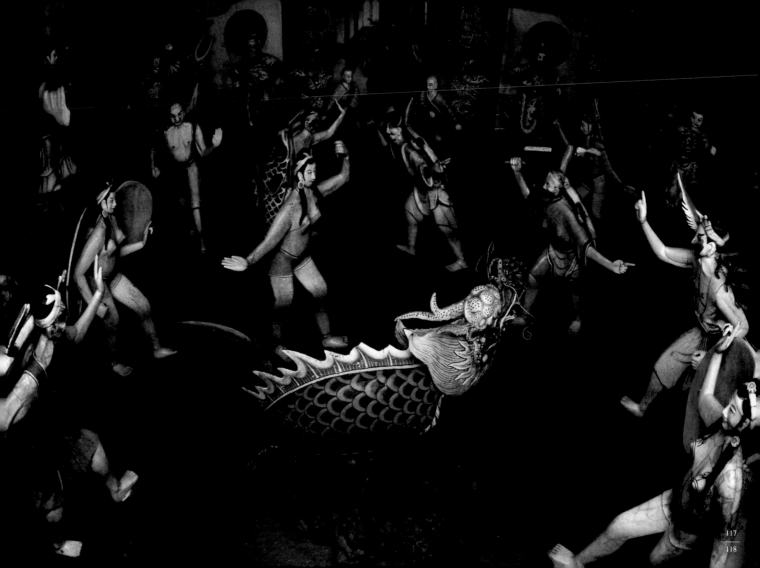

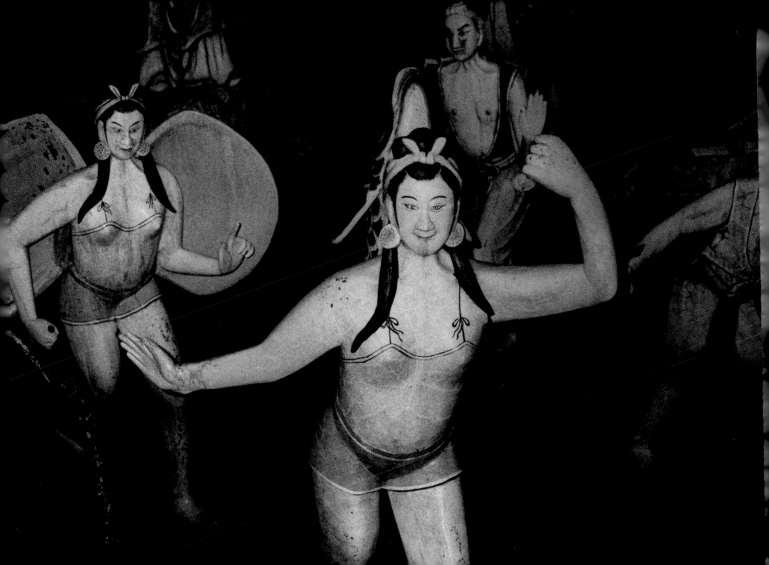

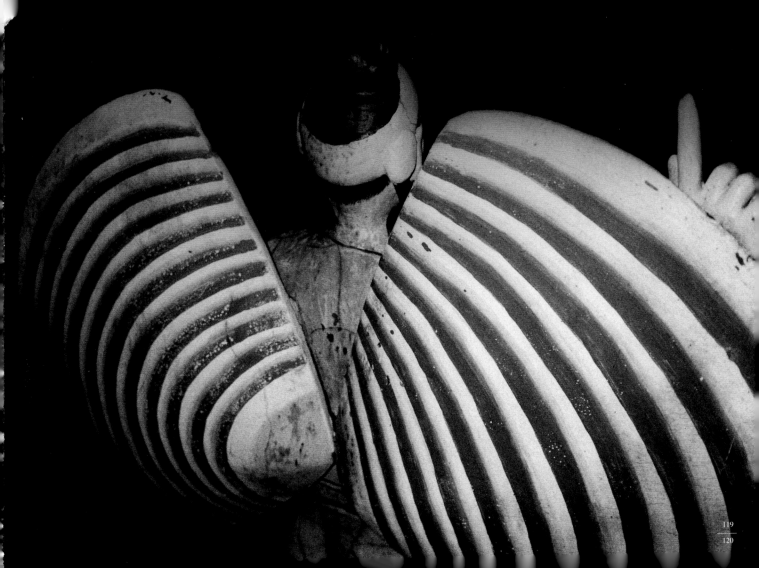

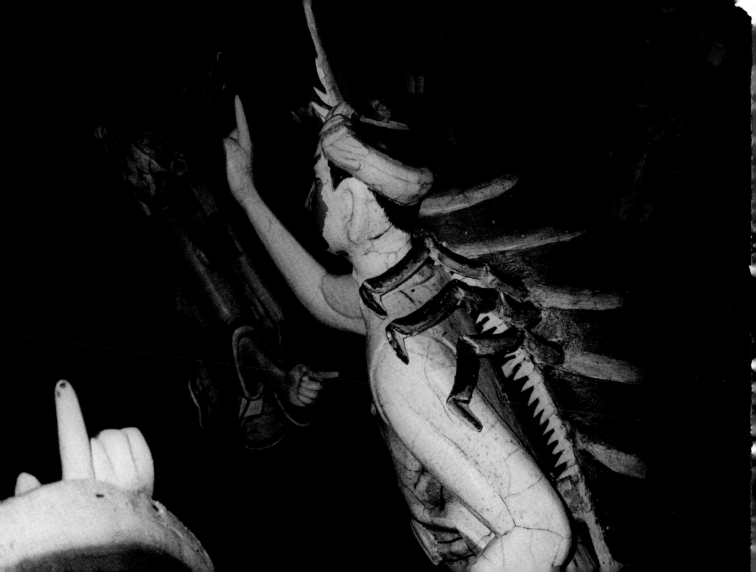

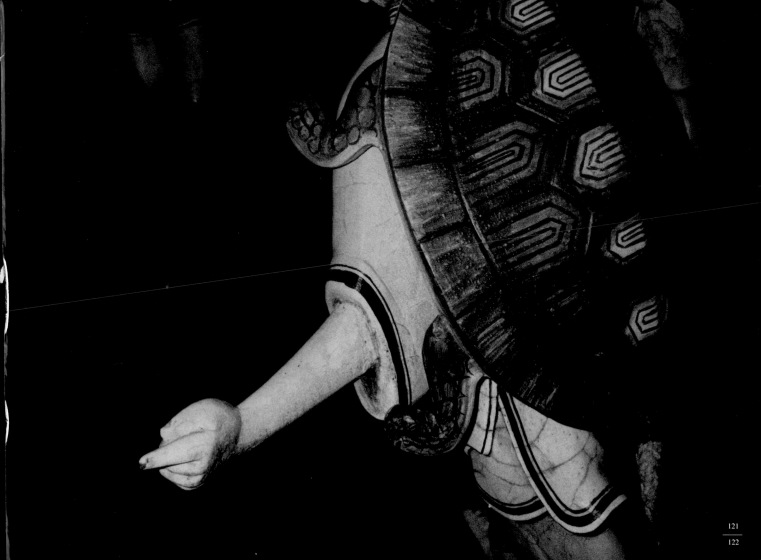

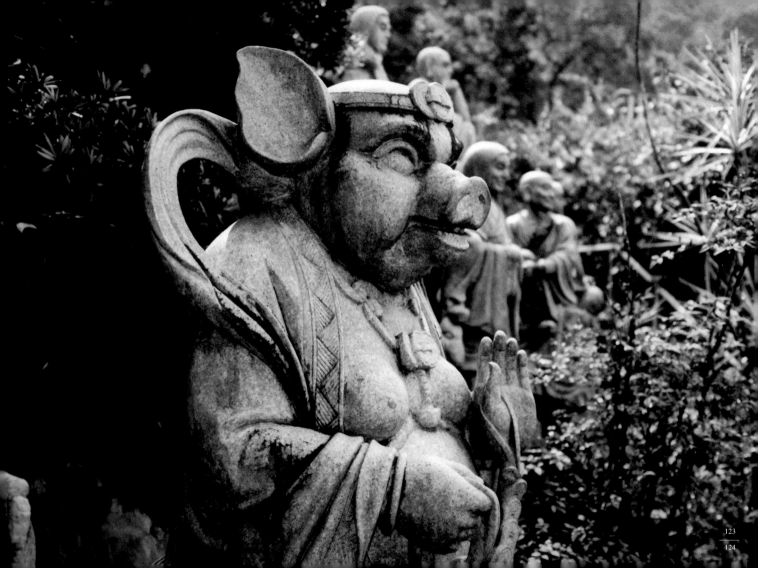

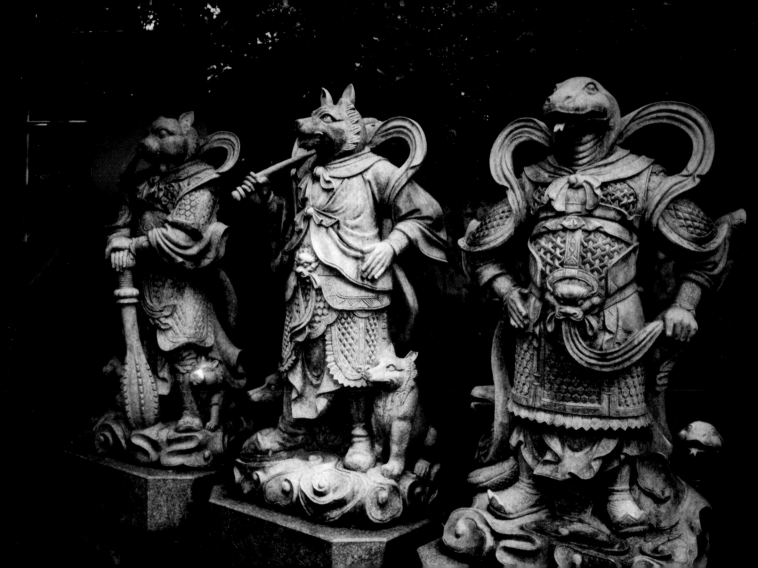

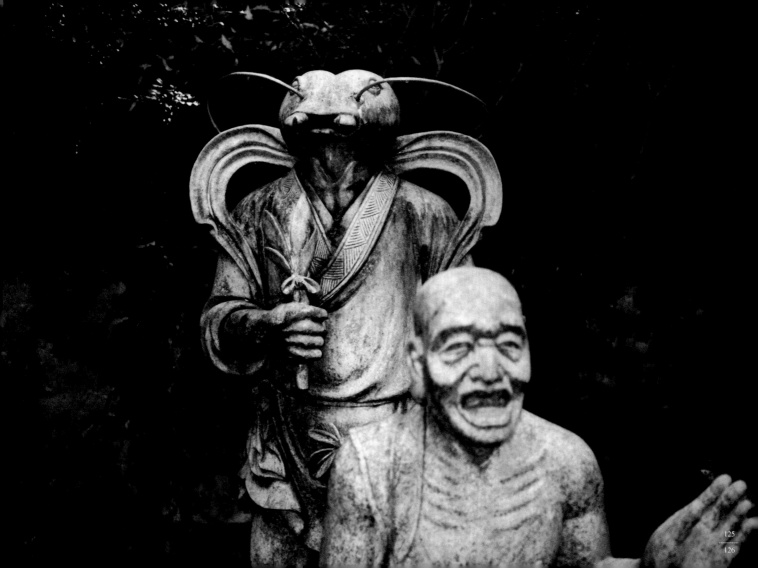

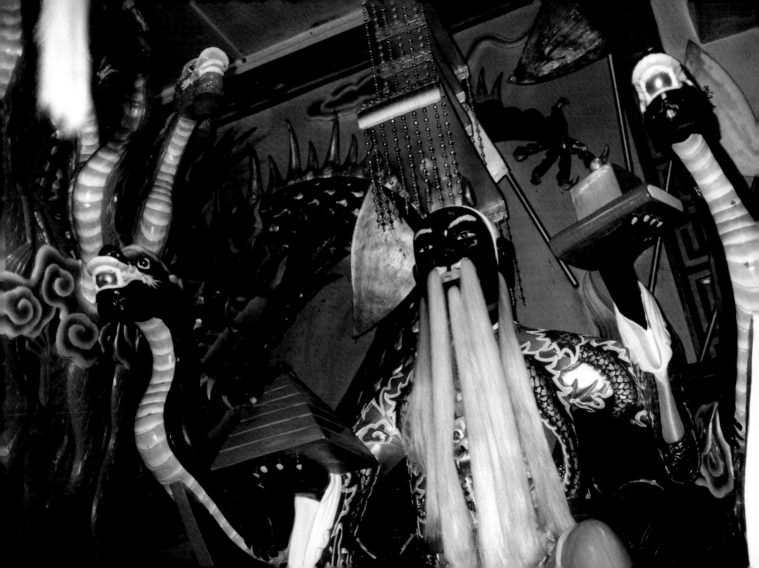

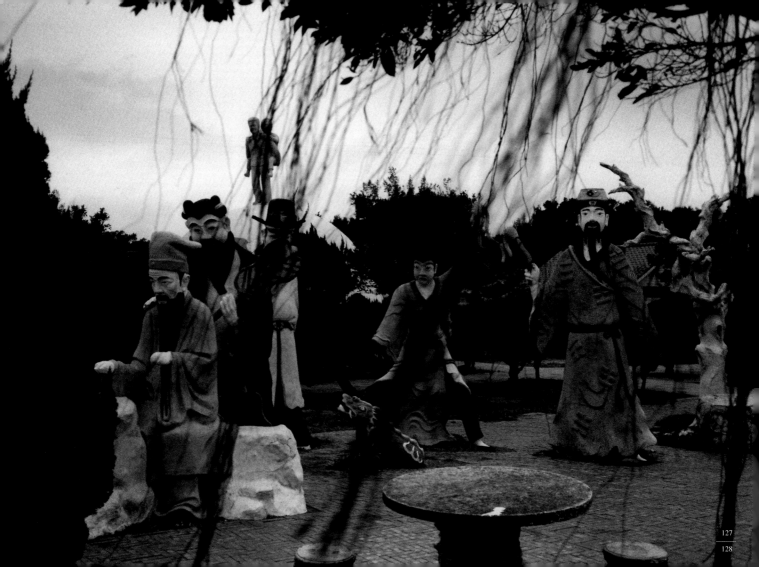

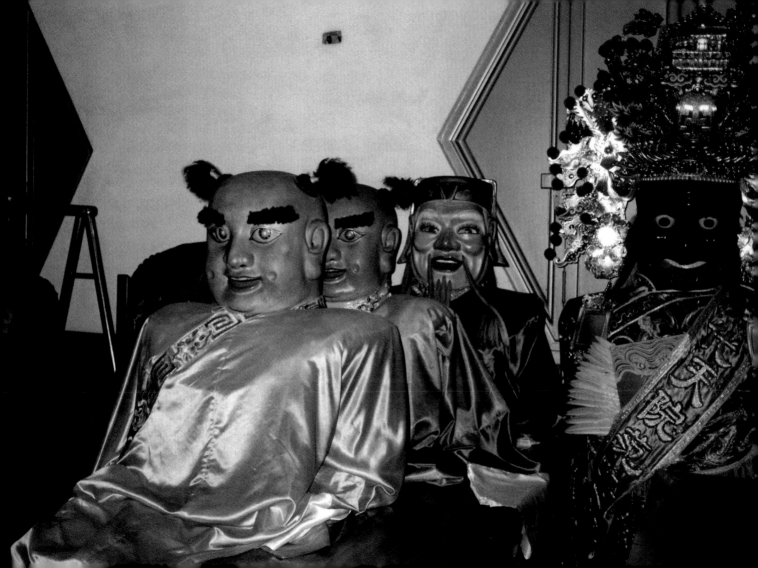

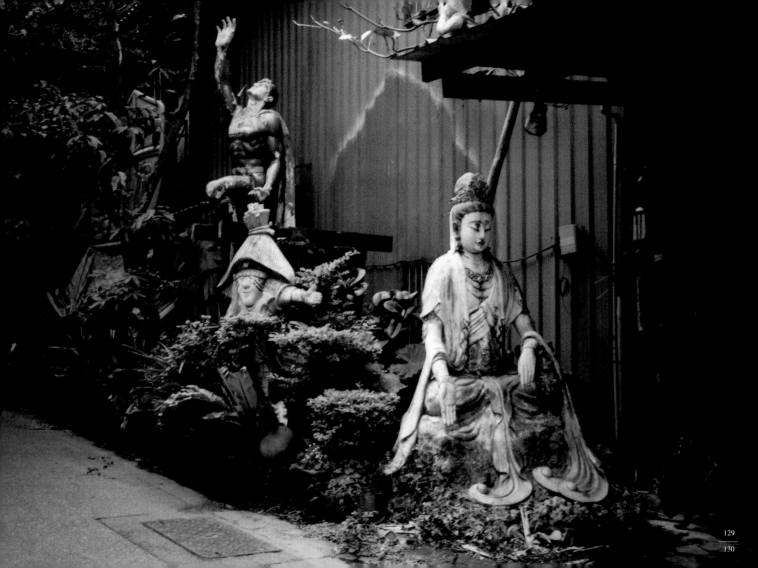

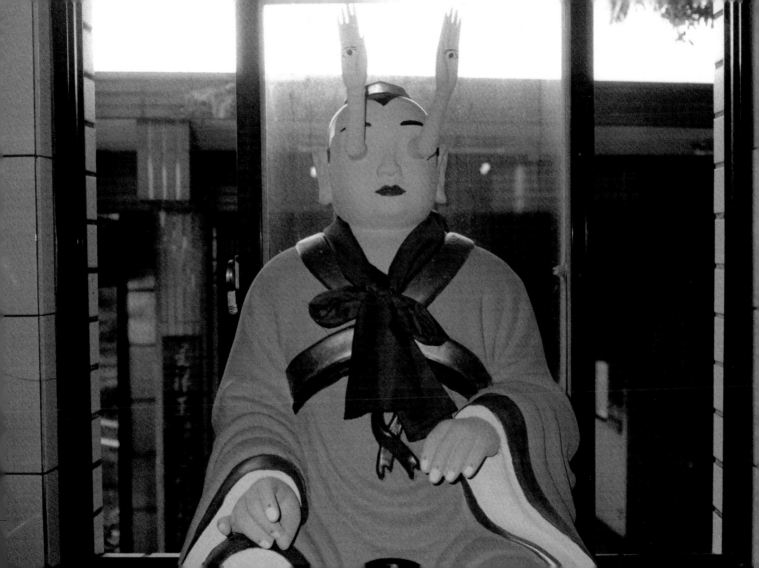

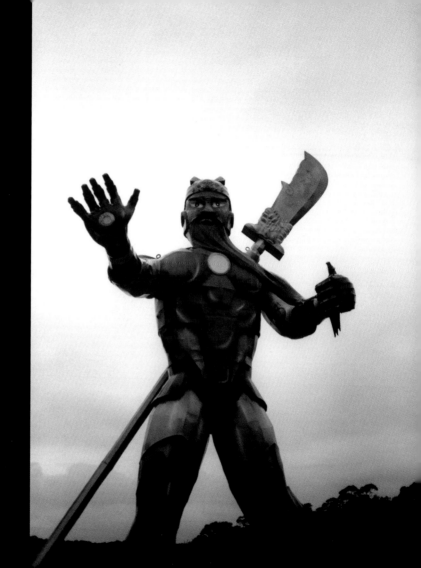

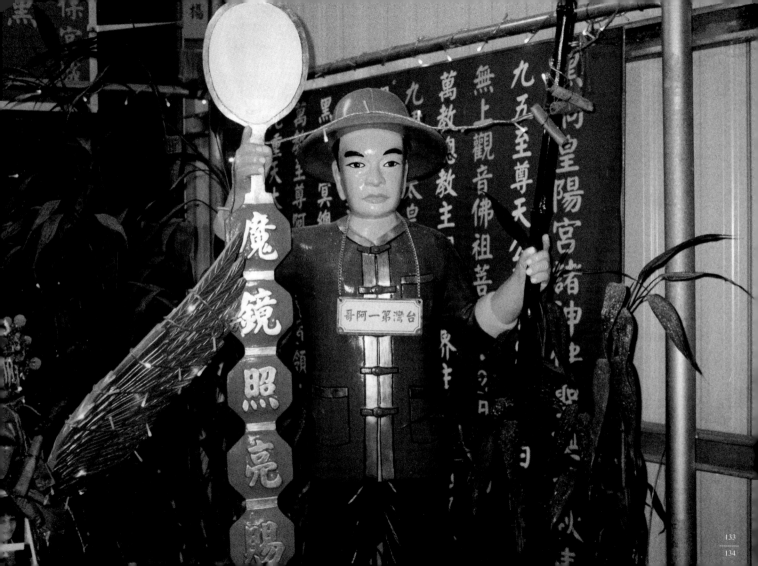

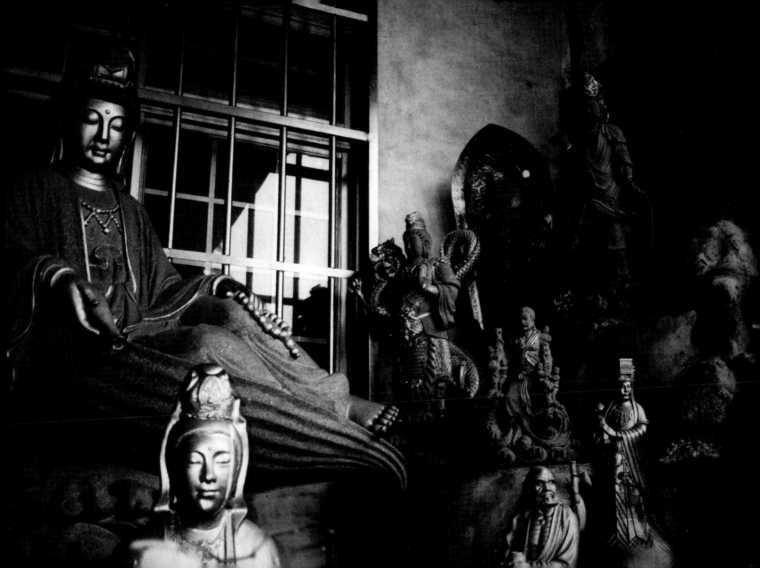

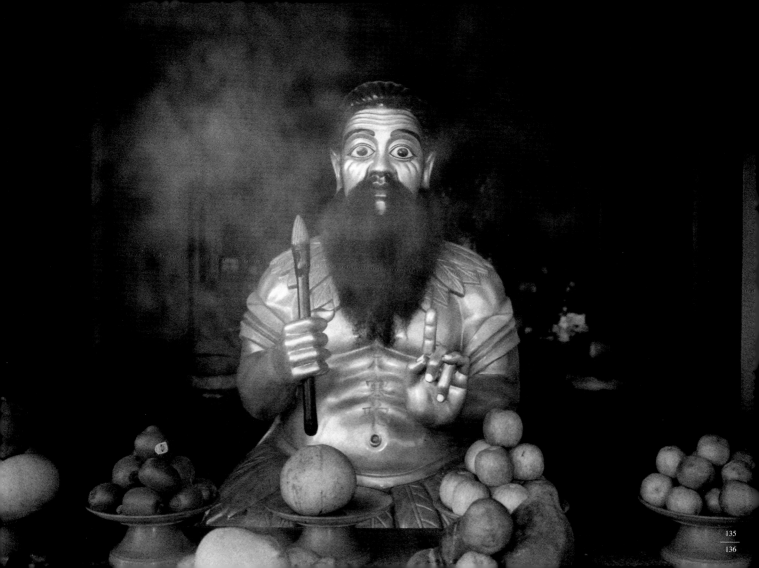

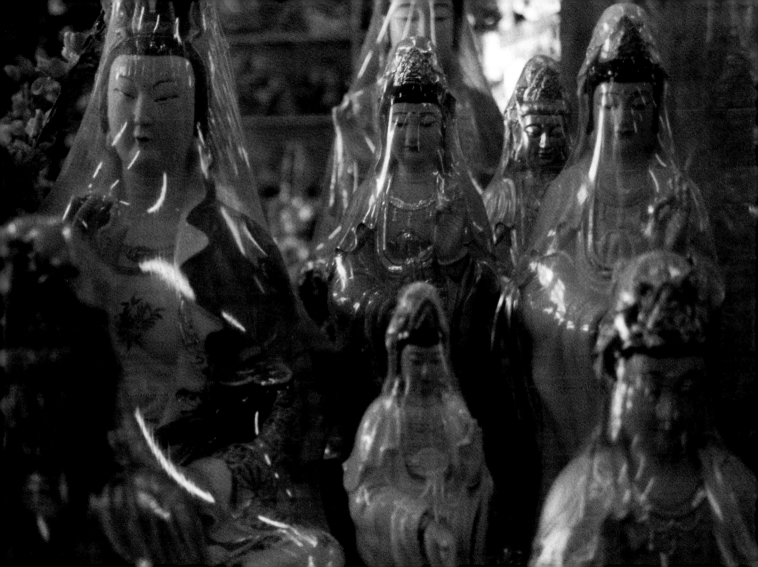

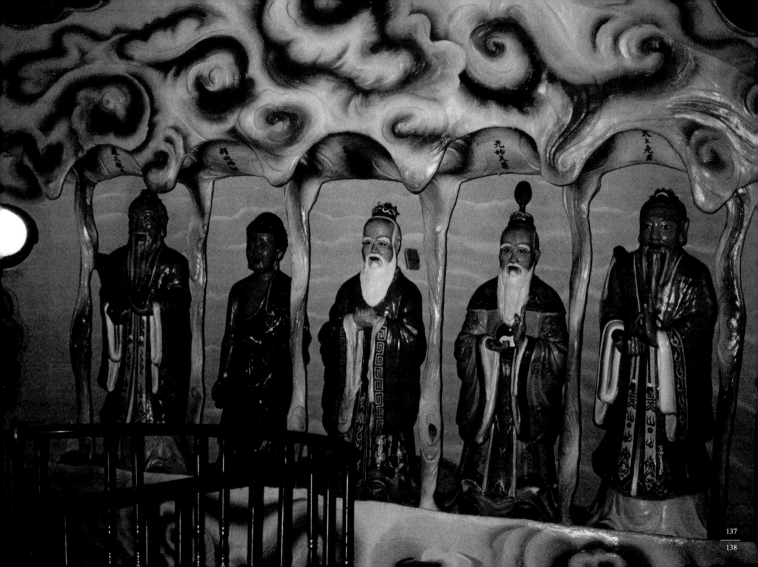

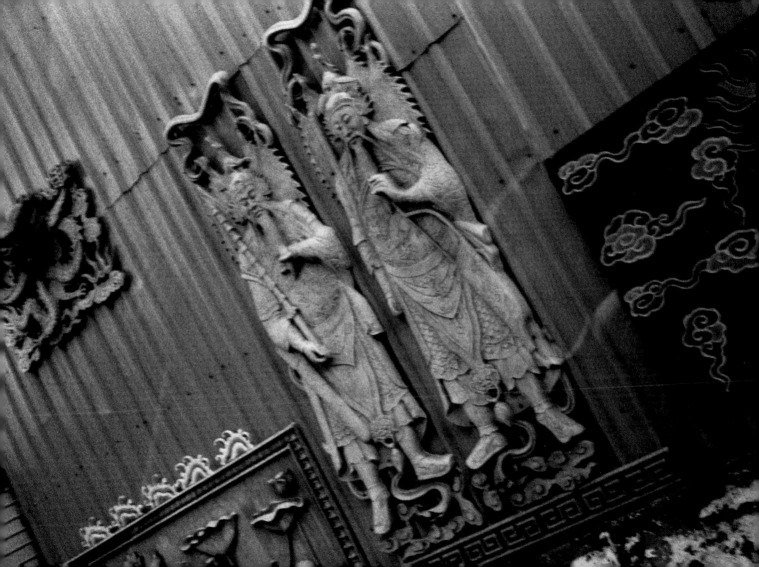

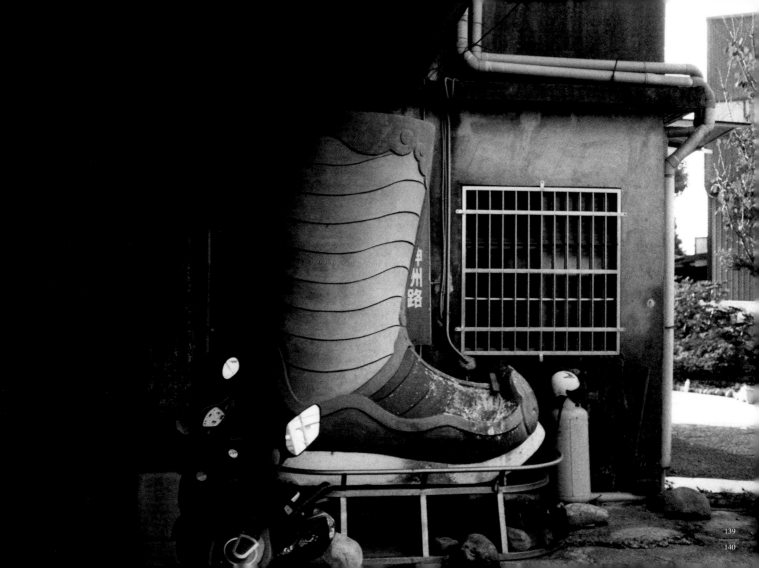

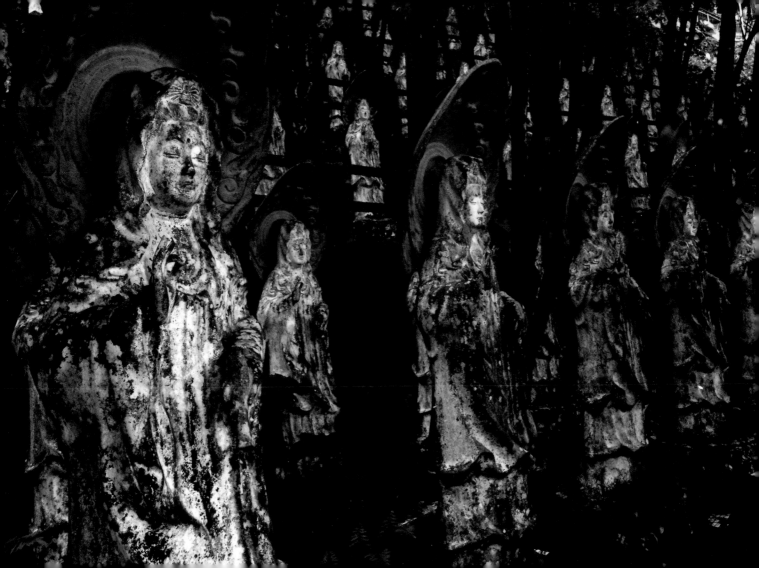

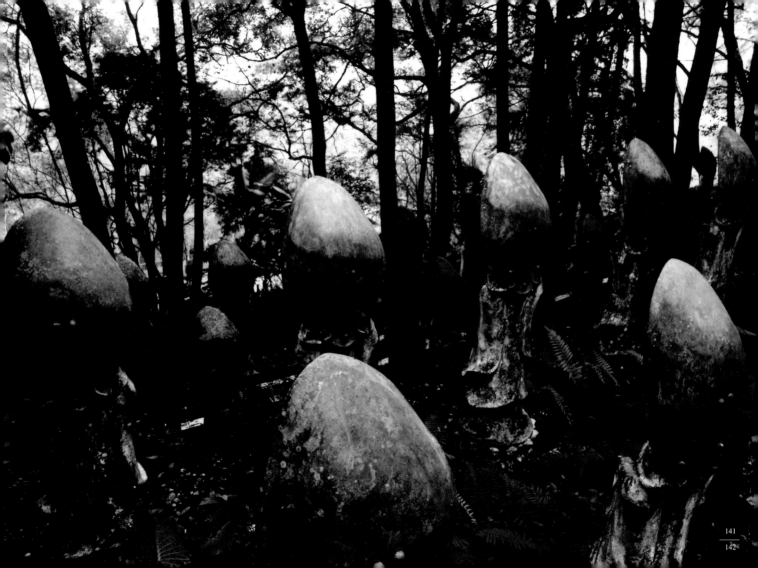

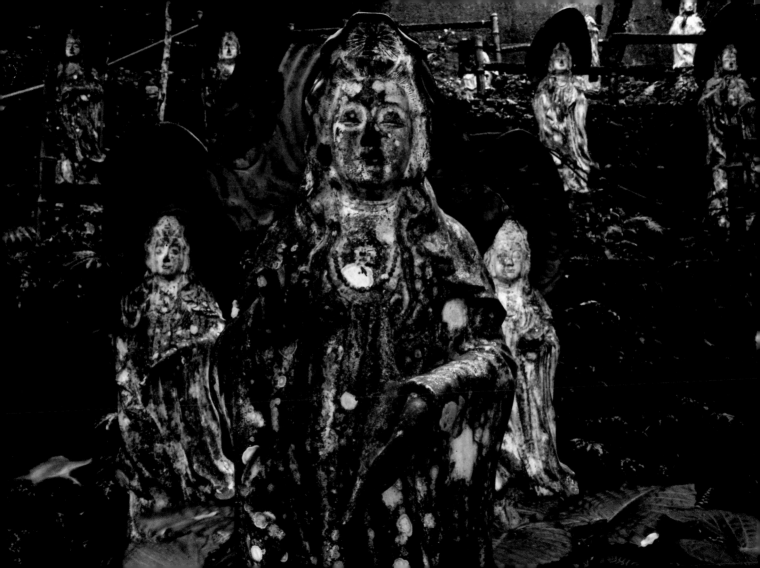

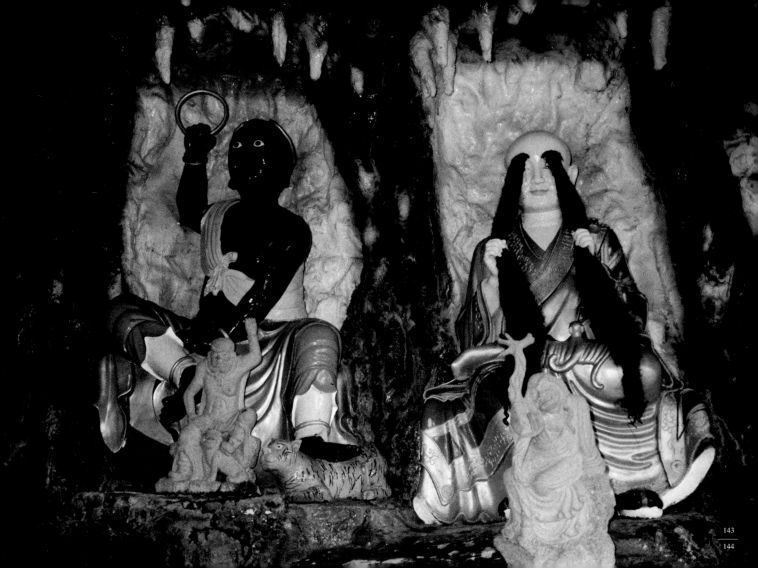

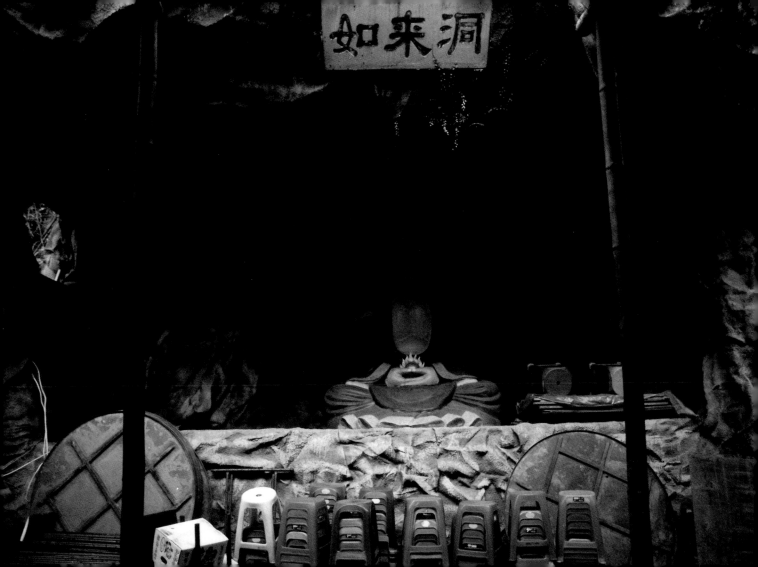

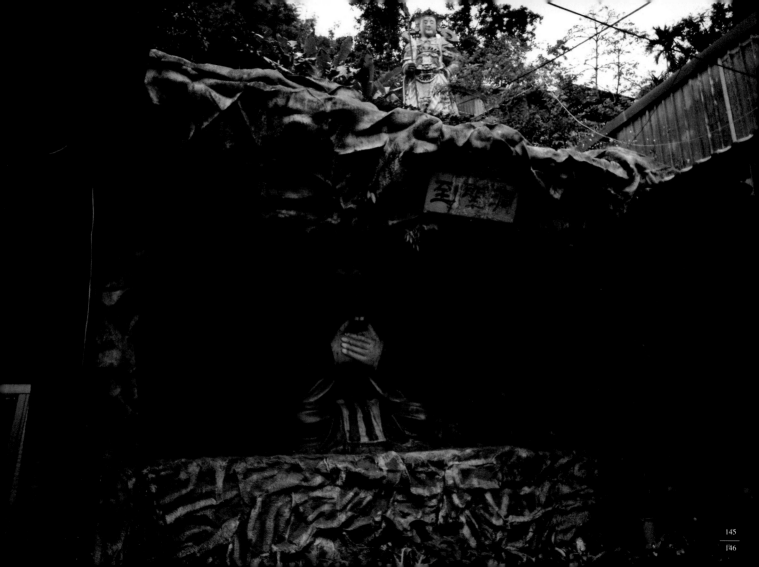

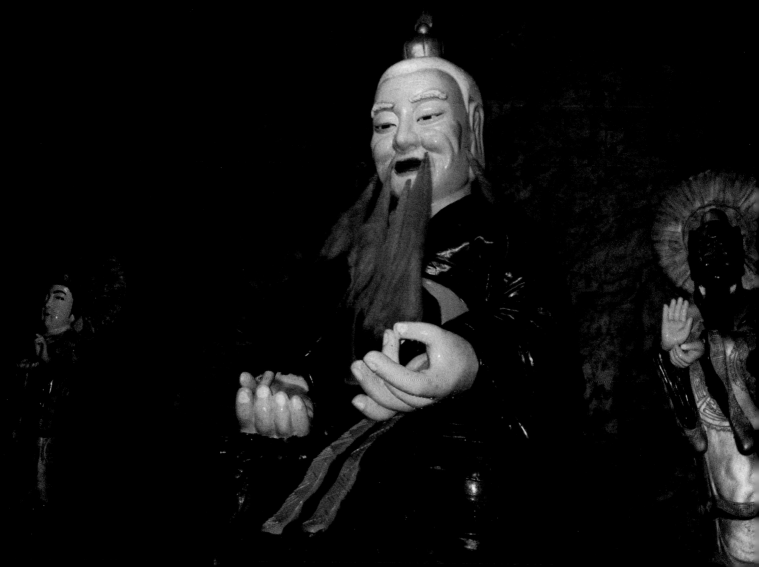

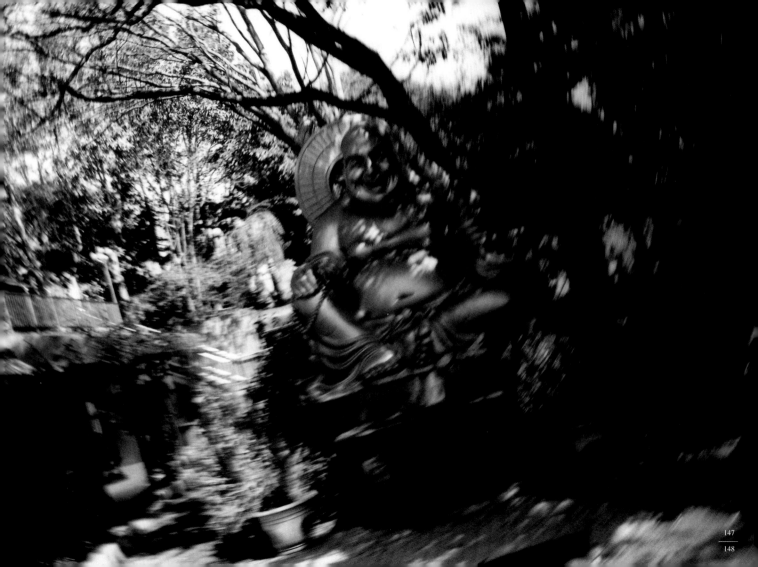

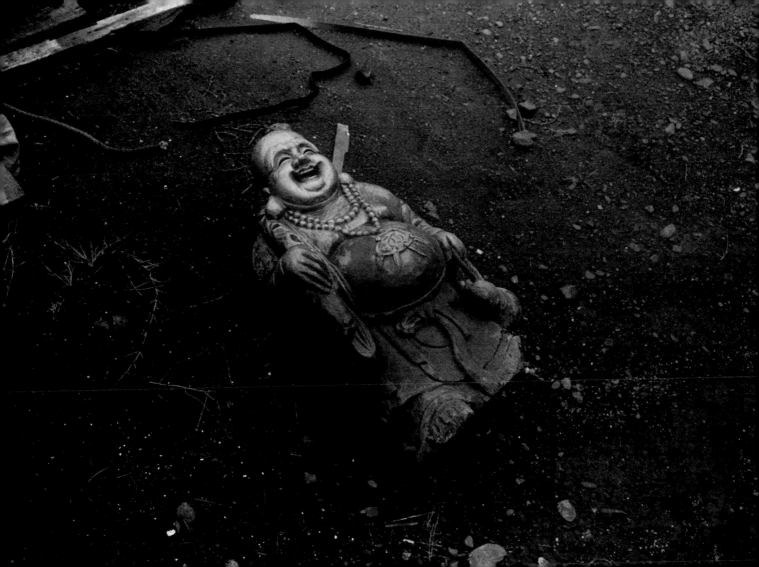

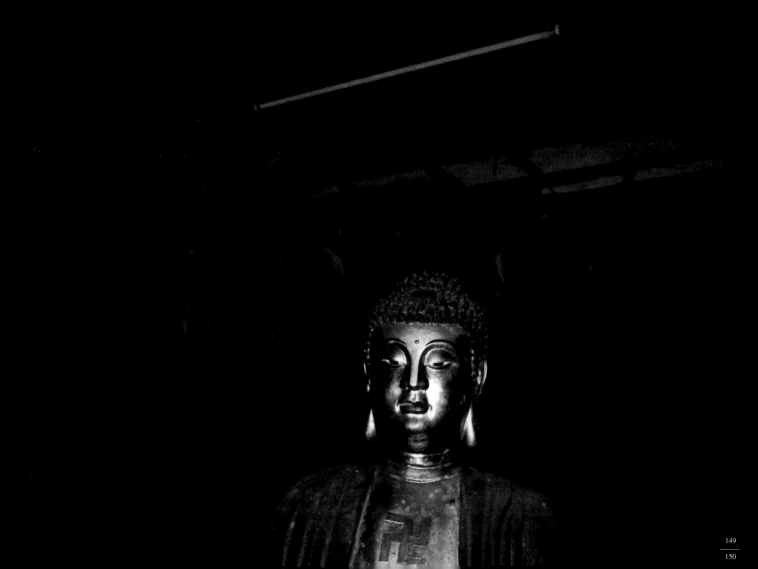

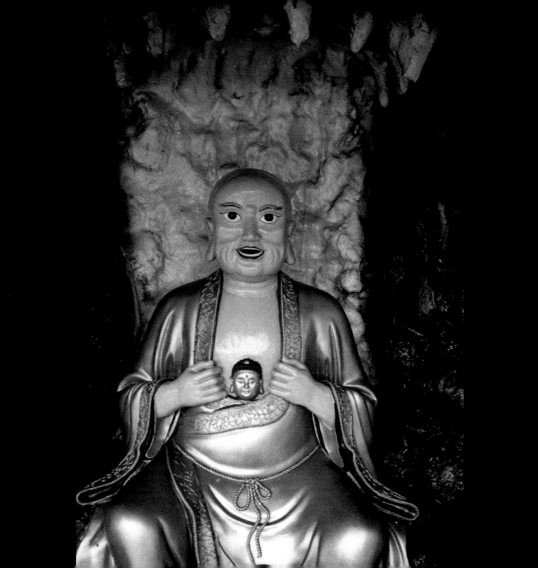

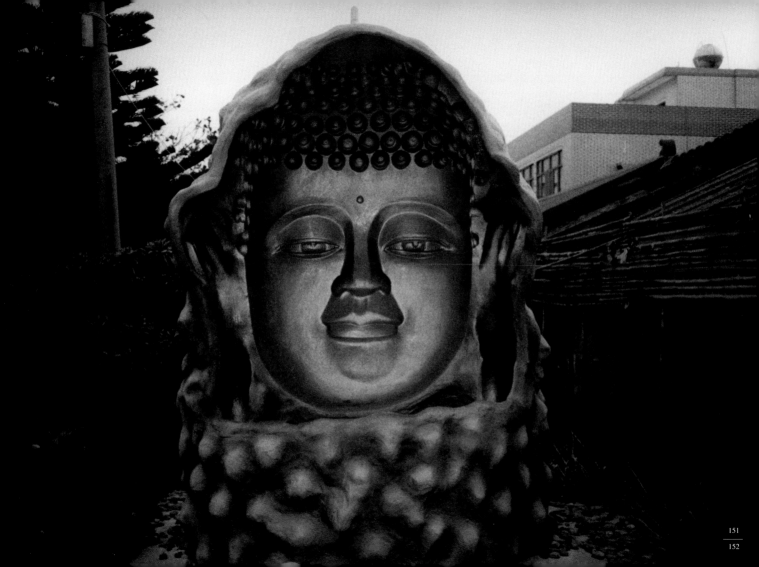

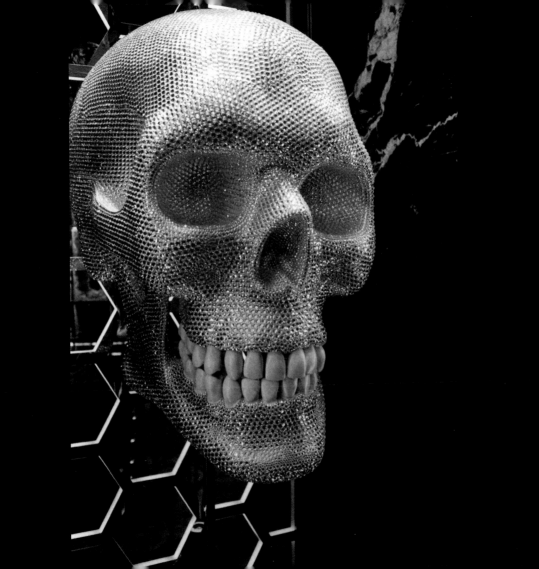

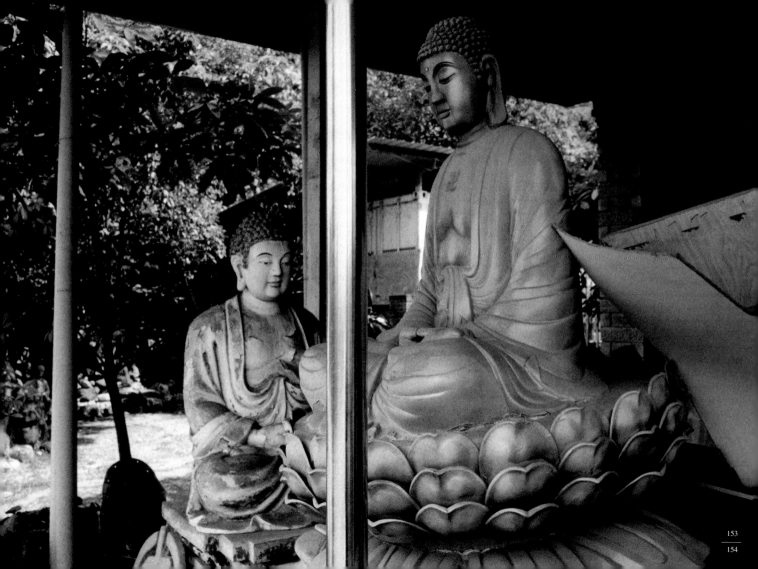

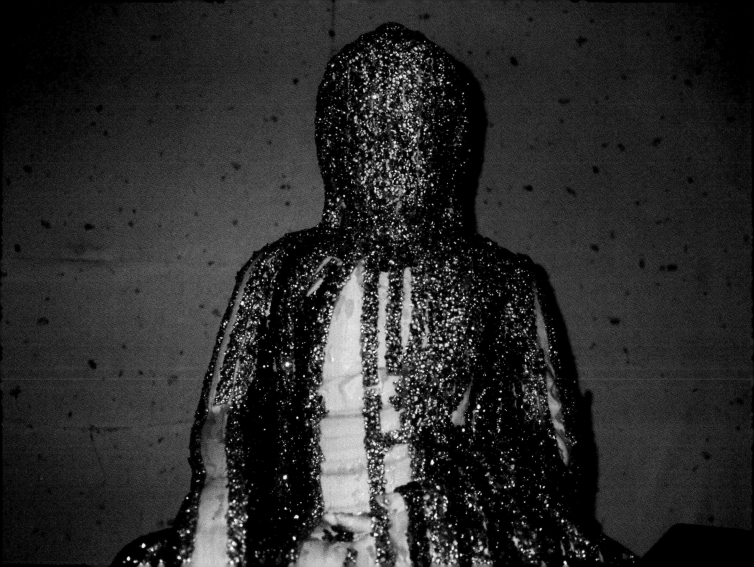

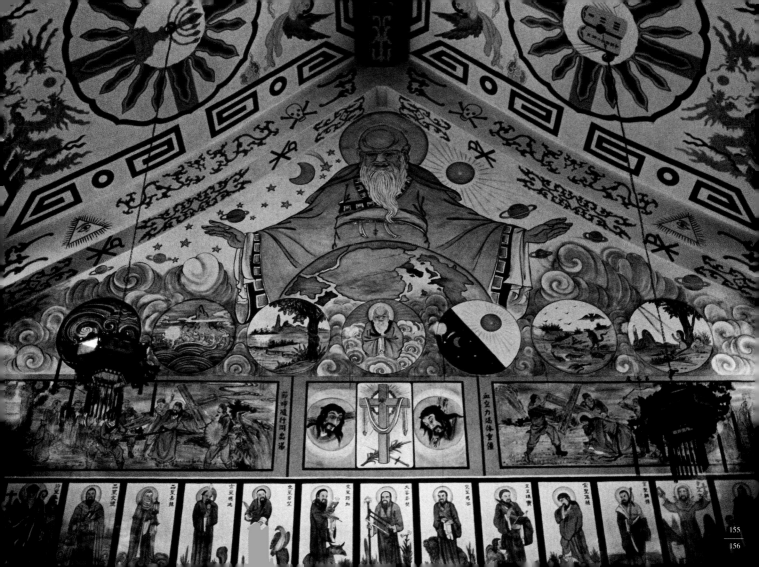

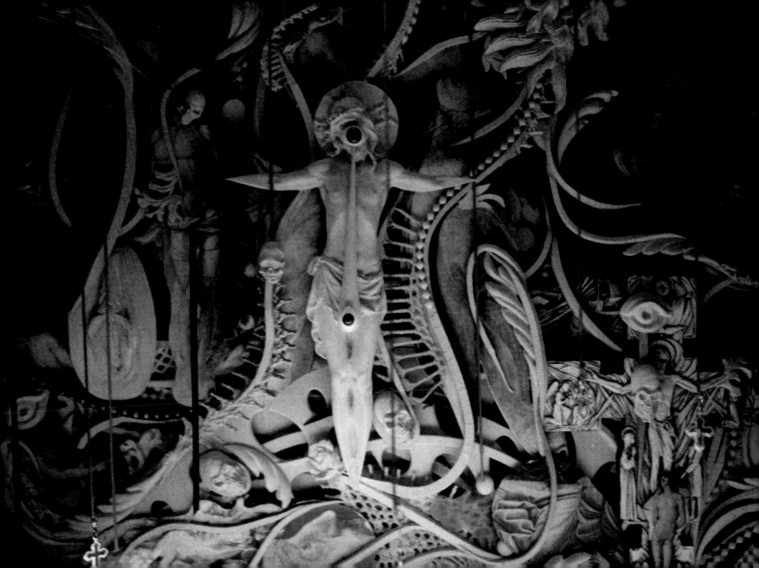

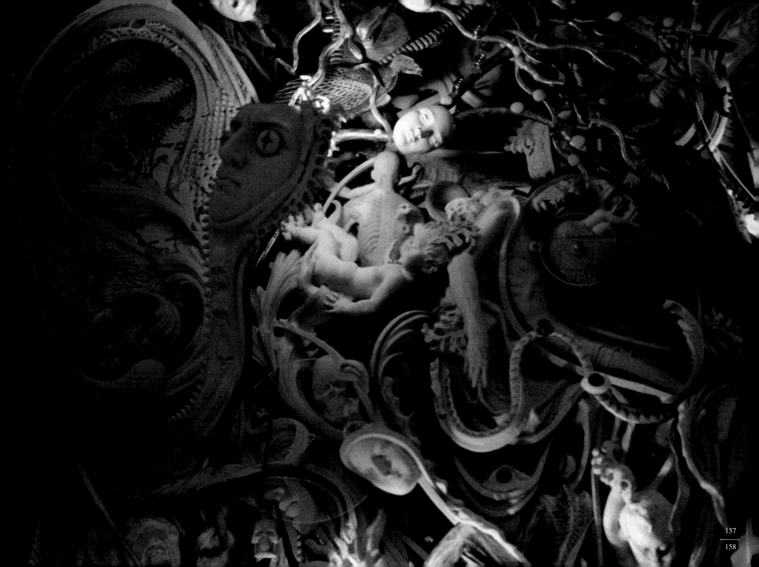

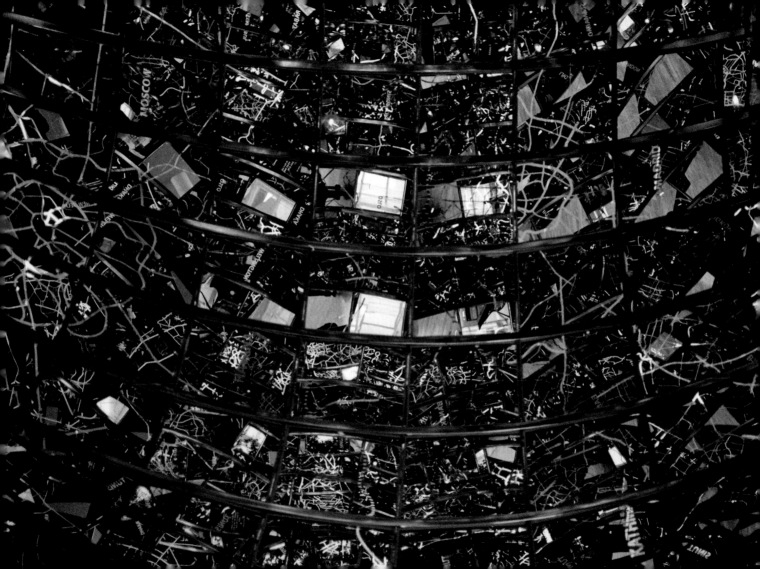

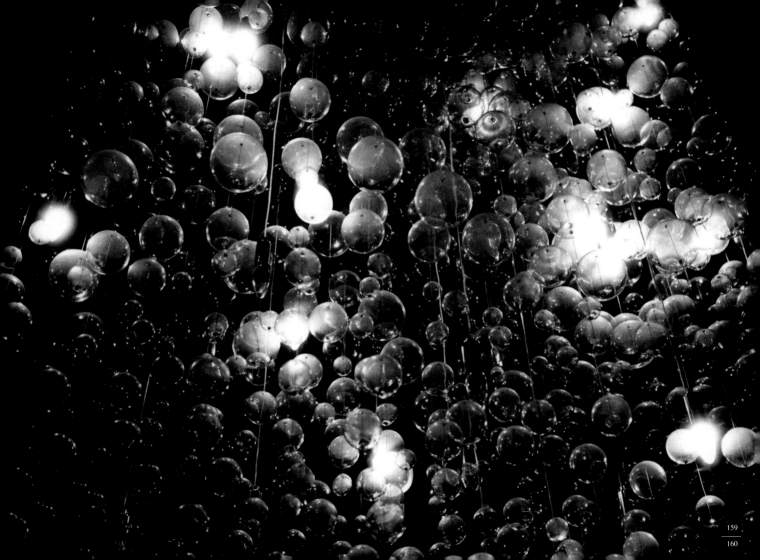

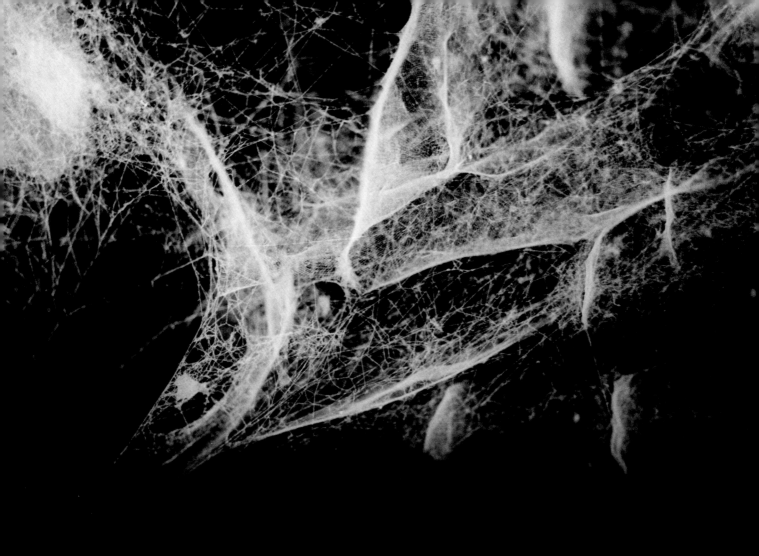

they cannot comprehend the nature of the void and even cling to the dichotomy of emptiness and existence and fall into the fallacy of the view that the individual has an unchanging self and the concept that one's consciousness ceases upon death. With such a mindset, there is no difference between an evil deed and a good deed, and one can be reborn as a human being again. On the other hand, what is the difference between them and animals if one is without shame, remorse, and esteem and is even unfeeling, lustful, and lascivious?

Minds are delicate and subtle, and all human behavior and actions come from the mind. Therefore, Mahayana Buddhism summarizes the "conditioned existence" into the "eight consciousness" (including eye, ear, nose, tongue, body, and mental consciousness, the deluded awareness, and the appropriating consciousness), fifty-one "mental factors" (the five pervasive functions, the

five specific states, the eleven good states, the six primary afflictions, the twenty secondary afflictions, and the four indeterminate dharmas). Among which, desire, enmity, ignorance, pride, doubt, and false views are the six primary afflictions. The twenty "secondary afflictions" refer to anger, enmity, vexation, concealing, deceit, flattery, haughtiness, harming, jealousy, stinginess, unscrupulousness, shamelessness, faithlessness, sloth, indolence, depression, flightiness, forgetting, incorrect knowledge, and scattering, are commonly committed by the general public. However, there are twenty-four kinds of "elements unassociated with the mind," including acquisition, life force, human commonality, nature of unenlightened sentient being, the concentration of non-conceptualization, the concentration of extinction, result of non-conceptualization, a group of names, a group of sentences, a group of text, birth, agedness, abiding, impermanence, transmigration, concomitance, rapid changes, sequence, direction, time, number, completeness, and incompleteness. And the eleven forms comprise eye, ear, nose,

Muddy Buddha
姚瑞中 Yao Jui-Chung

中翻英／官妍廷

The title "Buddha" is borrowed from Pali Buddho and abbreviated as Hut in Southern Min in Tang Dynasty. Briefly speaking, the title represents "the awakened one," who thoroughly comprehends the suffering of all sentient beings and achieves ultimate happiness through Prajna (wisdom). Therefore, "Buddha" is not a "deity" but the awakened one who comprehends the great doctrine of Tath gata (meaning "one who has thus come" in Pali), and is called by "World Honored One," "the Correctly Enlightened," "the Knower of the Secular World," "the Tamer," in the ten epithets. Buddhas of the past, present, and future come to the secular world to preach because of the concatenation of cause and effect. They are self-awakened and enlightening others, saving sentient beings from the painful obstruction. However, Prince Siddhartha Gautama, who had enjoyed all the glory and wealth in the secular world, gave up the opportunity to become a Chakravarti (wheel-turning sacred king) and practiced Tapas (meaning a variety of austere practice in Sanskrit) in the Himalayas six years. What exactly did he comprehend? There is no terminal point of the reincarnation of the six paths; is it possible to liberate all the sentient beings?

Buddha has attained enlightenment through practicing Dhutanga austerities . Before Shakyamuni attained "Annutara-samyak-sambodhi" (supreme correct enlightenment) under the Bodhi tree more than 2,500 years ago, the demon Mara sent his three daughters, identified as thirst, aversion, and desire, to tempt the World Honored One. However, when the demon found Shakyamuni remained unmoved, he sent out thousands of devil troops to threaten him; however, those shooting arrows from the troop became flowers scattered in the sky. At this point, if one was tempted to commit adultery and to become arrogant, they might fall into the path of demons, which is the so-called "state possessed by a demon" —being obstructed by great delusion without any awareness. In such a situation, one is not only unable to break free from the attachment to their ego but is also restricted

past two millennia, Theravada, Tibetan Buddhism, Han Buddhism, and Esoteric Buddhism have all developed a systematic and elaborate collection of Buddhist statues and sophisticated rituals, showing the profound depths of Buddhist art.

However, society is gradually deteriorating, and many religious groups are practicing individual worship and accumulating wealth by unfair means under the pretext of charity—many people claim to be living Buddhas and make false speeches. When one enters the realm of devils (Muddy), it is like falling into a trap where one cannot discern the world's true nature. In the name of Buddha, they develop a cult of personality and showed people their supernatural power. When one's "five aggregates" (matter of form, sensation, recognition, mental

Ultimate Bliss and Avici are determined and demonstrated by our thoughts. If all human beings eventually become ghosts and spirits, then what is death exactly? How can one escape from the "three realms" (the realm of sensual desire, the realm of form, and the formless realm of pure spirits)?

As a grumpy middle-aged artist with no significant strength and power, I also get lost in the pandemic over the past two years. However, I have been trying to reflect on the "every form is an illusion" thinking in ra gama S tra through monochrome photography I have done over the past ten years. Rather than naming this collection "an illustration book of caution," perhaps people need more of an

tongue, body, form, sound, odor, taste, and touch. In total, they form ninety-four "conditioned existence," referring to the dharma that appears, changes, and disappears in response to the development of cause and effect. As to the six "unconditioned existence," which is everything not subject to the principle of cause and effect, including tranquility of unconditional space, the tranquility of the unconditional and selected, the tranquility of the unconditional and unselected, the undisturbedness of unconditional space, non-sensation and non-thought of unconditional space, suchness of unconditional space.

When Buddha entered the ultimate state of soteriological release (the great Nirvana), he instructed Ananda to abide by the four "foundations of mindfulness" (to consider the body as impure and utterly filthy, to consider the sensation as always resulting in suffering, to consider the mind as being dependent and without nature, and consider things as impermanent). The preceptor (here, the

author refers to the "ten good deeds," including not to kill, not to steal, to avoid sexual misconduct, not to lie, abstention from slanderous speech, abstention from harsh speech, abstention from idle talk, non-greed, non-hatred, and right views) will be his guide, and he should always follow the dharmas instead of dharma masters. One should ever cling to "illusion" (or the nature of emptiness), let alone the human-made wooden or stone sculpture. Therefore, five or six centuries after the Nirvana of Shakyamuni Buddha, there were no statues of him to be worshipped. Still, the Buddha was only symbolically commemorated in pagodas and temples (as dharmachakra, ornaments, bodhi trees, pedestals, and niches). It was not until the 1st to the 5th century, when Gandhara (in present-day Pakistan and Afghanistan) and Mathur (north-central India) became the center of the Kushan Empire, that the thirty-two marks of the Buddha and the eighty secondary characteristics were gradually developed. The Buddha's statue was then made, and the believers could worship the statues, and Buddhism entered a period of divinization. Over the

p.027 國立臺灣自然科學博物館
 National Museum of Natural Science, Taichung City ©2020

p.028 國立臺灣自然科學博物館
 National Museum of Natural Science, Taichung City ©2010

p.029 德國卡塞爾
 Kassel, Germany ©2007

p.030 菲律賓馬尼拉
 Manila, Philippines ©2018

p.031 德國卡塞爾
 Kassel, Germany ©2007

p.032 國立臺灣自然科學博物館
 National Museum of Natural Science, Taichung City ©2010

p.033 義大利羅馬
 Roma, Italy ©2018

p.034 日本環球影城
 Universal Parks and Resorts, Japan ©2015

p.035 基隆市聖濟宮十八羅漢洞
 Eighteen Arhats Cave, Shengji Temple, Keelung City ©2021

p.036 土耳其伊斯坦堡
 Istanbul, Turkey ©2007

p.037 澳門
 Macao ©2019

p.038 韓國光州
 Kwangju, South Korea ©2015

p.039 澳洲珀斯
 Perth, Australia ©2018

p.040 苗栗縣通霄鎮秋茂園
 Qiu Mao yuan, Tongsiao Township, Miaoli County ©2020

p.041 韓國首爾樂天世界
 Lotte World, Seoul, South Korea ©2017

pp.042-046 韓國首爾樂天世界魔鬼屋
 The Haunted House, Lotte World, Seoul, South Korea ©2017

p.47 彰化縣彰化市南天宮
 Nantian Temple, Mt. Bagua, Changhua City, Changhua County ©2018

pp.48-49 嘉義縣竹崎鄉黑洞皇陽宮
 Temple of Black Hole & Emperor of Sun, Zhuqi Township, Chiayi County ©2022

p.050 新加坡虎豹別墅
 Haw Par Villa, Singapore ©2018

pp.051-053 基隆市中元祭
 Ghost Festival, Keelung City ©2021

p.054 高雄市鳥松區小南海觀音寺
 Xiao Nan Hai Temple of Avalokite⊠vara, Niaosong Dist., Kaohsiung City ©2022

p.055 台南市麻豆區麻豆代天府
 Madou Temple of the Heavenly Viceroys, Madou Dist., Tainan City ©2017

p.056 高雄市阿蓮區大崗山超峰寺
 Chaofeng Temple, Mt. Dagang, Alian Dist., Kaohsiung City ©2016

pp.057-060 嘉義縣水上鄉白人牙膏觀光工廠
 Whitemen Toothpaste Tourist factory, Chiayi City ©2019

魔地佛
Muddy Buddha
拍攝地點與年份

cover　苗栗縣南庄鄉獅頭山
Lion's Head Mountain, Nanzhuang Township, Miaoli County ©2021

back cover　宜蘭縣礁溪鄉寂光寺
Ji Guang Temple, Jiaoxi Township, Yilan County ©2022

pp.005-006　新竹市世博臺灣館（新竹市兒童探索館）
Hsinchu World Expo Taiwan Pavillion, Hsinchu City ©2019

p.007　澳門
Macao ©2019

pp.008-009　國立臺灣自然科學博物館
National Museum of Natural Science, Taichung City ©2020

p.010　高雄市旗山區開基八路財神廟
Temple of money God, Qishan Dist., Kaohsiung City ©2021

p.011　嘉義縣竹崎鄉黑洞皇陽宮
Temple of Black Hole & Emperor of Sun, Zhuqi Township, Chiayi County ©2022

p.012　台南市左鎮區某公園
Park , Zuozhen Dist., Tainan City ©2017

p.013　嘉義縣竹崎鄉黑洞皇陽宮
Temple of Black Hole & Emperor of Sun, Zhuqi Township, Chiayi County ©2022

p.014　台北市信義區象山天寶聖道宮
Tianbao Shengdao Temple, Mt. Elephant, Xinyi Dist., Taipei City ©2017

p.015　國立臺灣自然科學博物館
National Museum of Natural Science, Taichung City ©2007

p.016　花蓮縣豐濱鄉女媧娘娘廟
Nuwa Temple, Fengbin Township, Hualien County ©2022

p.017　新竹縣寶山區某民宅
Private House, Baoshan district., Hsinchu County ©2021

pp.018-019　國立臺灣自然科學博物館
National Museum of Natural Science, Taichung City ©2007

p.020　苗栗縣通霄鎮秋茂園
Qiu Mao yuan, Tongsiao Township, Miaoli County ©1999

pp.021-023　新加坡虎豹別墅
Haw Par Villa, Singapore ©2018

p.024　台北
Taipei ©2018

p.025　國立臺灣自然科學博物館
National Museum of Natural Science, Taichung City ©2020

p.026　國立臺灣自然科學博物館
National Museum of Natural Science, Taichung City ©2010

p.136　馬來西亞檳城極樂寺
Temple of Ultimate Happiness , Penang, Malaysia ©2018

p.137　基隆市大佛禪院
Dafo Ch'an Monastery, Keelung City ©2019

p.138　台北市五股區某工廠
a Factory, Wugu Dist., New Taipei City ©2021

p.139　台中市神岡區聖德宮
Sheng De Temple, Shengang Dist., Taichung City ©2022

pp.140-142　苗栗縣南庄鄉獅頭山
Lion's Head Mountain, Nanzhuang Township, Miaoli County ©2021

p.143　宜蘭縣頭城鎮九股山菩提觀佛修院
Temple of Bodhisattva, Toucheng Township, Yilan County ©2021

pp.144-146　台北市信義區北臺慈惠堂
North Taiwan Cihuei Court, Xinyi Dist., Taipei City ©2019

p.147　苗栗縣苗栗市宇宙大佛千佛寺
Thousand Buddha Temple of Cosmic Buddha, Miaoli City, Miaoli County ©2022

p.148　屏東縣枋山鄉金朝陽宮
Golden Sun Temple, Fangshan Township, Pingtung County ©2019

p.149　新竹市東區古奇峰普天宮
Putian Temple, Guqi Peak, East Dist., Hsinchu City ©2021

p.150　宜蘭縣頭城鎮九股山菩提觀佛修院
Temple of Bodhisattva, Toucheng Township, Yilan County ©2021

p.151　雲林縣四湖鄉西天寺
Temple of Western Paradise, Sihu Township, Yunlin County ©2022

p.152　義大利羅馬
Roma, Itily ©2019

p.153　台南某工廠
a Factory, Tainan ©2022

p.154　韓國首爾
Seoul, South Korea ©2017

p.155　彰化縣鹿港鎮天主堂
Catholic Church, Lukang Township, Changhua County ©2018

pp.156-157　菲律賓馬尼拉
Manila, Philippines ©2018

p.158　韓國首爾
Seoul, South Korea ©2017

p.159　高雄市鼓山區某旅館
a Hotel, Gushan Dist., Kaohsiung City ©2022

p.160　義大利威尼斯
Venice, Italy ©2019

p.161　臺灣桃園國際機場
Taiwan Taoyuan International Airport ©2018

p.162　國立臺灣自然科學博物館
National Museum of Natural Science, Taichung City ©2020

p.163　嘉義縣水上鄉北回歸線太陽館
The Solar Exploration Center at the Tropic of Cancer, Chiayi ©2022

p.164　韓國首爾樂天世界
Lotte World, Seoul, South Korea ©2017

p.061 新竹縣北埔鎮中元普渡
Ghost Festival, Beipu Township, Hsinchu County ©2020

pp.062-064 新北市石門區金剛宮
Phra Phrom Temple, Shimen Dist., New Taipei City ©2016

p.065 新北市泰山國民運動中心
Taishan Civil Sports Center, New Taipei City ©2020

pp.066-070 新加坡虎豹別墅
Haw Par Villa, Singapore ©2018

p.071 新竹縣北埔鎮中元普渡
Ghost Festival, Beipu Township, Hsinchu County ©2020

pp.072-076 高雄市阿蓮區大崗山超峰寺
Chaofeng Temple, Mt. Dagang, Alian Dist., Kaohsiung City ©2016

p.077 新竹縣北埔鎮中元普渡
Ghost Festival, Beipu Township, Hsinchu County ©2020

pp.078-082 台南市麻豆區麻豆代天府
Madou Temple of the Heavenly Viceroys, Madou Dist., Tainan City ©2018

p.083 新北市三峽區九鳳山無極七玄宮
Wuji Temple of Seven Mysteries, Sanxia Dist., New Taipei City ©2022

pp.084-089 新北市林口區青嶺湖北文紫祥宮包公廟
Temple of Lord Bao, Qingling Lake, Linkou Dist., New Taipei City ©2018

p.090 高雄市大寮區吳進生佛教藝術館
Wu Jinsheng Buddhist Art Museum, Daliao Dist., Kaohsiung City ©2022

p.091 新竹市東區古奇峰普天宮
Putian Temple, Guqi Peak, East Dist., Hsinchu City ©2021

pp.092-122 基隆市聖濟宮十八羅漢洞
Eighteen Arhats Cave, Shengji Temple, Keelung City ©2021

pp.123-125 新北市三峽區如來禪寺
Temple of Tathagata Zen, Sanxia Dist., New Taipei City ©2022

p.126 嘉義縣竹崎鄉黑洞皇陽宮
Temple of Black Hole & Emperor of Sun, Zhuqi Township, Chiayi County ©2022

p.127 苗栗縣通霄鎮秋茂園
Qiu Mao yuan, Tongsiao Township, Miaoli County ©1998

p.128 嘉義縣竹崎鄉黑洞皇陽宮
Temple of Black Hole & Emperor of Sun, Zhuqi Township, Chiayi County ©2022

p.129 新北市中和區烘爐地旁工廠
Nanshan Temple of the Village Deity, Zhonghe Dist, New Taipei City ©2022

p.130 新北市石門區金剛宮
Phra Phrom Temple, Shimen Dist., New Taipei City ©2016

p.131 新竹市東區古奇峰普天宮
Putian Temple, Guqi Peak, East Dist., Hsinchu City ©2021

p.132 新北市中和區烘爐地旁工廠
Nanshan Temple of the Village Deity, Zhonghe Dist, New Taipei City ©2022

p.133 嘉義縣竹崎鄉黑洞皇陽宮
Temple of Black Hole & Emperor of Sun, Zhuqi Township, Chiayi County ©2022

p.134 新北市三峽區如來禪寺
Temple of Tathagata Zen, Sanxia Dist., New Taipei City ©2022

p.135 雲林縣台西鄉靈雲山靈雲寺哲學廟
Temple of the North Deity, Yunlin County ©2022

Catch 288
魔地佛 Muddy Buddha

作者：姚瑞中
翻譯：官妍廷（中翻英）

責任編輯：趙曼孜
封面設計：黃子欽
美術設計：簡廷昇

法律顧問：董安丹、顧慕堯律師
出版者：大塊文化出版股份有限公司
台北市 105022 南京東路四段 25 號 11 樓
www.locuspublishing.com

讀者服務專線：0800-006689
TEL：（02）87123898　FAX：（02）87123897
郵撥帳號：18955675　　戶名：大塊文化出版股份有限公司

版權所有　翻印必究
總經銷：大和書報圖書股份有限公司
地址：新北市新莊區五工五路 2 號
TEL：（02）8990-2588（代表號）　　FAX：（02）2290-1658
製版：瑞豐實業股份有限公司
初版一刷：2022 年 11 月
定價：新台幣 880 元

ISBN 978-626-7206-09-6
Printed in Taiwan

國家圖書館出版品預行編目(CIP)資料
魔地佛 = Muddy Buddha/姚瑞中著. -- 初版. –
臺北市：大塊文化出版股份有限公司, 2022.11
面；　公分. -- (Catch ; 288)
中英對照

ISBN 978-626-7206-09-6(精裝)
1.CST: 攝影集

957.9　　　　　　　　　　　111014109

Buddhya Buddhya · sambodhani sambodhaya.
覺　　　　　　　正覺　　妙覺

Cala Cala Calandu
轉　　動

Sarva varanani
一切　降礙

Sarva pàpa vigaite Haru Haru
一切　罪業斷除 ~~淨除~~ 拔濟

Sarva soka vigate
一切　眾苦斷陰

Sarva Tathàgate Hrdaya Vajreni sambhara sambhara
一切　如來心　金剛寶篋 俱足資糧：

Sarva Tathàgata Cuhya Dharani mudre
一切　如來　秘密 總持 法印。

Buddhe Subuddhe
佛智　妙智

sarva Tathàgatàdhisthite
一切　如來加持

Dhàtu Garbhe sàhà
法界　寶藏 圓滿成就

samayàdhisthite Svàhà
三昧 加持　　圓滿成就

Sarva Tathàgate Hrdeya Dhàtu Mudre Svàhà
一切 如來 心　界　印 圓滿成就

supratisthita stupe, Tathàgatàdhisthite.
妙勝建立　寶塔 如來加持。

Haru Haru · Hùm Hùm svàhà
拔濟　　　吽　吽 圓滿成就

om. Sarva Tathàgatausnisa Dhàtu Mudràni
嗡　一切 如來佛頂 法界 總持印

sarva Tathàgatàm · Sadhàtu vibhusitadhisthite
一切 如來　同等法身 莊嚴加持。

Hùm Hùm svàhà
吽　吽 圓滿成就

②　　　　　③